Face Forward

By Julian C. R. Okwu

Face Forward

Young African American Men in a Critical Age

CHRONICLE BOOKS

SAN FRANCISCO

Library of Congress Cataloging-in-Publication Data:

Okwu, Julian C. R.

 Face forward : young African American men in a critical age / by Julian C. R. Okwu

 160 p. 24.5 x 25.4 cm.

 ISBN 0-8118-1631-1. (hc) —ISBN 0-8118-1215-4 (pb)

 1. Afro-American young men—Portraits. 2. Afro-American young

men—Interviews. I. Title.

 E185.86.038 1997

 305.38'896073—dc20 96-42319 CIP

Book and cover design: Sandra McHenry Design

Cover photograph: Kevin Ladaris, by Julian C. R. Okwu, 1997

Printed in Hong Kong.

Distributed in Canada by

Raincoast Books

8680 Cambie Street

Vancouver, B.C. V6P 6M9

10 9 8 7 6 5 4 3 2 1

Chronicle Books

85 Second Street

San Francisco, CA 94105

Web Site: www.chronbooks.com

This book is dedicated to the memory of my friend Revels M. Cayton, who passed away in November 1995. His spirit epitomizes how all of us related to *Face Forward* aspire to live our lives.

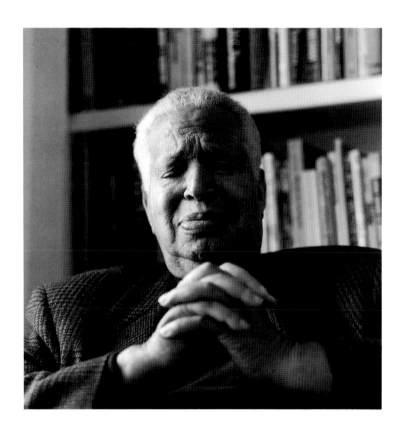

Contents

Acknowledgments

Face Forward has evolved from concept to reality because of the enthusiasm and interest of the thirty-nine men who greeted me with trust and hospitality. Each one of them, through their experiences and their acceptance, informed me about the direction of this project. My deep appreciation goes out once again to each and every one.

Along the way, the following people and institutions provided me with everything from operational support, to invaluable advice: Nell Bernstein, Laura Blom, Yvette and Leifer Bonaparte-Thor, Billy Bragman, Marcel Cairo, Morrie Camhi, Darcy Cohan, Ronald Colthirst, Don Cornwell of Granite Broadcasting, Jennifer Daggy, Davis Black & White, Kathy Eldon, the San Francisco Public Library, Bill and Elwanda Fenwick and the Fenwick family, Joseph Folberg and the Vision Gallery family, Lydia Galvan, Xan Garlick, Lowell Gibbs, Marnie Gillett and San Francisco Camerawork, John Gilligan, Debra Heimerdinger, Sid Hollister, Hunter House Publishers, Claudia Jackson and the Do Something Foundation, Charlie Kreiner, Judy Krasnick, Lisa Lee, the LEF Foundation, Adam and Naomi Levine, Michael Levine, Lynn Luckow, Arlene Mays, Heather McDaniel, Charles McNeil, Maritza Myers, Constance Reed, Lauren Schwartz, Gordon Sellars, Ernst Wildi and Tony Corbell of Victor Hasselblad, Inc.

Extraordinary support for *Face Forward* was received from Dr. Revels Cayton and the entire Cayton family. His contributions were above and beyond any of my expectations.

As a first-time author I have been surprisingly blessed by teaming up with a stellar publishing company in Chronicle Books. That fortune was only surpassed during the editing phase when I was able to witness the professionalism, faith, and patience of my editor Annie Barrows and her assistant Karen Silver. To this day I don't know how they put up with me.

By approaching the photographic printing as if the photographs and the resulting book were his own, André Cypriano of André Cypriano Photography provided me with remarkable images, professional insight, and a valuable friendship. He is no doubt one of those exceptional people who maintains the delicate balance of immense talent and genuine humility.

From the initial stages of this project, Marina Drummer, Executive Director of the LEF Foundation, has inspired me to stay focused through the confidence, trust, and unparalleled commitment she has exhibited towards *Face Forward*.

Very special thanks are also due to Julie Racinet and Michael Woolsey for their unconditional support and for persevering through all facets of a work-in-progress—both the book-kind and the human-kind.

I have gleaned exceptional examples and mentors from many areas of my life, two of whom—although they were not aware of their role—are Keith Carter and Sebastiao Salgado. However, the first, and the most consistent, have been my parents: Drs. Beatrice and Austine Okwu, and my brothers: Augustine Nkem, Francis Chiedo, Oscar Nnamdi, and Michael Chiaka.

I am indebted to everyone above for sharing in the vision and the emotion of *Face Forward*.

Face Forward

Young African American Men in a Critical Age

Introduction

My parents, four older brothers, and I moved to Connecticut in 1970, after living in Nigeria, England (the country of my birth), Tanzania, and Washington, D.C. It was not a simple transition, even for a four-year-old boy ready for an adventure. Our new classmates found it difficult to place us in a context familiar to them; what could they do with these dapper little brown faces that spoke with British accents and swore they were from Nigeria—a country the students associated with a continent of huts and wildlife? Thinking back, it's impossible to determine which group—the black students or the white students—were more uninviting. Thankfully, there was a handful of intrepid young students who put their expectations and stereotypes on hold until they had an opportunity to understand us for who we were, rather than for what we appeared to be.

Strangely enough, the genesis of *Face Forward* can be attributed to those students. They proved to me that there is so much to gain when we reserve judgment until after we have had a chance to understand an issue, or, as in this case, a group of people. With this insight, I set out to introduce the personalities of young African American men to a world that had already defined them based on demographic statistics. In addition, I gave myself a path to understand that same group of men who share my daily experiences but not my ancestral history.

One of the most common questions people ask me about *Face Forward* is "Why did you decide to do the book?" The answer, though painful to recount, comes from an experience I had on a San Francisco street. A photographer was composing a photograph in front of me. Though every pedestrian before me had crossed her path and interrupted her composition, I decided to walk into the street and around her in an effort to allow her to continue her creative process. As I passed her, she whispered what I thought sounded like, "Stay with your own kind." I gave her the benefit of the doubt and kept walking, but as I neared the end of the block, the clarity and the vehemence of her voice rang louder in my mind. I turned on my heels and approached her, but when I got about ten feet away, she raised her voice and warned me to "stay away," to "stop bothering her." My attempt to reason with her proved futile, and before I could decide on another strategy, she spat on me. There I stood, on the corner of Vallejo and Columbus streets, with her saliva running down my face, illogically refusing to wipe it off with my bare hands.

As I struggled to understand the reality of the situation, another man had crossed the street. My hope was that he would confirm what I thought had just transpired and validate my shock and anger. Instead, he proceeded to assist the woman down the street, leaving me with the words, "Why don't you just leave her alone?" I must say it was *his* behavior—his assumption that I was the source of trouble—that ignited my investigation into the reactions white people have toward African American men.

Some of my white friends break into tears when they hear that story for the first time. My black friends, however, identify with my experience and get angry. Ironically, I am almost grateful for that event, because it forced me out of my middle ground. It made me acutely aware of the visceral responses my presence and my visage as a black man generate, and of the statistics and images that fuel those responses. In addition, the reaction my white friends had to the story highlighted the absolutely disparate worlds our two races live in. They could not comprehend something like that happening in 1993 in the most progressive city in the country. Once again, my black friends were different; they followed up my story with anecdotes of their own.

After that realization, I noticed—before it became a national controversy—the different shades of *blackness* of O.J. Simpson's face on the covers of particular national news magazines. I was aware that *Time* magazine failed to display *any* positive images of African Americans on their cover for one entire year. Instead, images of Louis Farrakhan accompanied by the title "Minister of Rage," a dying Rwandan baby in the arms of her fly-covered mother, and an apparent mugshot of a Chicago boy prominently framed by the words "Kill" and "Die" were all cover shots.

Though these examples are legitimate stories and should be handled by the news media as such, there are no opposing cover stories. There is a clear and dramatic void when one tries to find a story or image to balance the examples above. While efforts continue to bring one-sided reporting to light, the tendency of town hall meetings, panel discussions, magazine covers, and the like is still to make individuals represent their entire race, and to require them to defend their positions for the group rather than just for themselves. Inevitably, this results in an exchange of defensive barbs and rhetoric, rather than a simple exchange of ideas in an effort to understand.

While I was in college at Dartmouth, there was a series of racist and sexist incidents that were followed by attempts at campus-wide healing. These included a "Take Back the Night" march, day-long symposiums on race relations, letters to the editor of the school paper, protests in the middle of the campus green, a surge of groups founded to promote public discourse, and sundry other events. All of the above were necessary to quell the tension, yet those students who most needed to hear the message—on both sides of the issue—rigidified their positions. They perceived the healing activities as organized personal attacks. Though attacks might have been understandable under the circumstances, the unfortunate result was that the goal of enlightening the perpetrators of the racist and sexist acts was not reaching its end. The message was falling on deaf, and, most importantly, self-plugged ears.

Americans are in the business of peddling statistics. The belief is that whoever dispenses the most statistics has the most authority. We hear sound bites calling African American men "endangered." We hear about African American mortality rates, college attendance estimates, incarceration percentages, and much more. Even publications intended to promote the American-ness of African Americans present a limited picture. It is a powerful perspective and one that is becoming definitive. Whites, blacks, and all other hues can expect that at some point the statistics will define the group. That is why such percentages remain in the research books and do not appear on these pages. Negative statistics have a way of handcuffing themselves to all things African American, and, in effect, cloud the ultimate message.

Face Forward is a way to disseminate information to the public without personal attacks, rhetoric, or blame. Its goal is to introduce forty men who are a part of the group defined by these negative statistics but who are not contributors to the statistics. To become intimate through these interviews and photographs with Michael Gibson, Derek Smith, and Matthew Hampton, among others, is to gain a greater understanding of a group of men commonly maligned by many, including themselves.

In his marvelous 1989 book called *I Dream a World*, a collection of seventy-five photographs of and interviews with African American women, Brian Lanker celebrated the countless contributions African American women have given to society. Thanks to his inspirational approach to addressing an issue, I have been able to focus for the past two years on a greatly misunderstood group—African American men aged eighteen to thirty. Several friends expressed concern about my ability to find enough men who had achieved a considerable amount by

such a young age. This turned out to be a non-issue for two reasons: there were too many men to choose from, and their qualifications for the book stemmed from something more intangible than a résumé or curriculum vitae. Sometimes it came from an inner awareness of where they were heading or where they had come from. Sometimes it came from a desire to leave a legacy in the minds of their children or the children of others. At other times, it came from a desire to have African Americans represented in areas they don't often frequent.

I wanted to introduce the world to another side of young African American men. Although you may not agree with all of their ideas, or identify with their politics, or understand their frustration, my hope is that you will recognize that they are all positive representatives of a subset of society that has become defined by negativity.

As I speak to elementary schools, universities, and after-school programs about *Face Forward*, I have asked the audience to list names of any African American men they can think of. The highest number of votes, by far, goes to Michael Jordan. That, in itself, is not something to be ashamed of. However, when all of the other votes go to athletes or rappers, then that image begins to define what it is to be an African American man, rather than individual African American men defining the image for themselves. This is why I focused on the men in the following pages. Some, like Congressman Fields and Omar Wasow, are in the news often. Others are not so well-known, but are equally noteworthy. More stories like theirs are needed to present a truer depiction of African American men.

How did I find the men who are featured in *Face Forward*? The more people heard about this project, the more help I received. In addition to engineering two grants, Marina Drummer of the LEF Foundation supplied me with names of potential participants, and as was usually the case, those names led to others. I spent a great deal of time gently harassing the employees at San Francisco's Main Public Library for relevant microfiche and ethnic newspaper databases. Another friend, Michael Woolsey, has come to know everyone through his work in the community, and he purged his database for additional names. Instead of six degrees of separation, I experienced only three. Of course, the men themselves were instrumental in pointing me to other candidates.

My early interviews followed a plan I had set from the very beginning: I wanted to meet with the profiled men at least three times before ever bringing a camera onto the scene. I also planned to leave my tape recorder at home for the first meeting. The idea behind this strategy

was that introducing either one of these two instruments too early in our relationship would affect our exchange and thus preclude a true presentation of the individual. Of course, when I realized that most of the subjects would come from other areas of the country, carrying out that plan became a short-lived fantasy. However, the remaining interviews—some conducted on multiple sessions over the telephone, others in person—proceeded just as smoothly as the early interviews.

I did not have a set list of questions for each man; however, I always asked about their experiences with racism—those they perpetrated as well as those they experienced at the hands of others. I also sought pivotal moments in their lives and the importance of what they were currently doing. The shortest interview took one hour and the longest four. For a range of reasons, three people declined to participate. Most of the men I contacted were exceptionally gracious and went beyond the call of duty in allowing me to probe many sensitive areas of their lives.

Once an interview had been completed, I arranged the photograph. I wanted to take the photographs in locations where each man felt comfortable or centered. On three occasions, that led us to Golden Gate Park in San Francisco; once, to the middle of a 7th Avenue sidewalk in Manhattan at lunchtime; and once to a church pew in the Bronx thirteen minutes before he had to conduct the service.

From the beginning, the goal of *Face Forward* has been to understand and to be understood. Personally, I needed to understand who African American men were because in this country, that is what people believe I am. In reality, I am a permanent resident of the United States, with Nigerian heritage and a British passport. Similarly, I wanted to introduce readers to young men who are too often seen only as the constituents of a group, though they are, in actuality, from widely varied backgrounds.

I gained great inspiration from these men. I have mentioned to them that I felt I was in a privileged position: through their honesty and accessibility, I received an education not only in their different professions, but also in various perspectives on ethnicity. I was able to observe the love they had for their families, churches, jobs, and co-workers. I saw the amount of strength one needs—and gains—working and living for something greater than oneself.

Their goals were not indicative of the phrase, "I've got to get mine," but rather, "What can I do for my family, my country, my people, and my future." These men are able to tap into that strength and persevere despite the prejudices, obstacles, and low expectations others may have for them. If nothing else, that strength is something I hope will be remembered and cherished by all those who meet, through this book and its traveling exhibition, the men of *Face Forward*.

James Baldwin once wrote in his novel *Another Country*,

It takes strength to remember; it takes another kind of strength to forget. It takes a hero to do both. People who remember court madness through pain, the pain of the perpetually reoccurring death of their innocence, and people who forget court another kind of madness: the madness of the denial of pain and the hatred of innocence. And the world is mostly divided into madmen who remember and madmen who forget. Heroes are rare.

You will find that these men have remembered and they have forgotten. You will also find, as I have, that they are heroes in the truest sense.

—*Julian C. R. Okwu*

Ben Jealous

Born January 18, 1973. **Raised by politically active parents, Ben has followed in their footsteps, becoming a tenacious community organizer and leader. He's worked with the homeless, fought landlords for the rights of low-income housing residents, and successfully protested Columbia University's bid to end financial aid. In fact, though he is now a graduate of Columbia, the university once suspended him over one of his protests. One summer he completed a national speaking tour for the AFL-CIO regarding the environmental hazards surrounding NAFTA. He has also organized protests for Mississippians for Higher Education, among others. He resides in Harlem, New York.**

My parents moved to California seeking an area that was racially tolerant. My father is white and my mom is black. In 1966 they got married in Washington, D.C. They had wanted to get married in Baltimore, but it was illegal. They ended up returning to Baltimore for the wedding reception. Because of the marriage, my father was disowned by his family, whose involvement in Massachusetts, Maine, and New Hampshire goes back to the 1600s.

One of the things that I realize about growing up in Carmel Valley, California, is that my family was part of a subculture whose members were ostracized from the social groups they had been raised in. My father was very involved in the men's pro-feminist movement, and my mom worked as a social worker. When I was younger, maybe four or five, my mom would take me to work with her because she couldn't afford to put me with anybody else. We would see all of these people who were suffering. Both of my parents really had an influence on me.

A big part of my upbringing was the understanding that poverty was sometimes something you ended up in because of your political beliefs. You could either invest in making money, which gave you one type of security, or you could invest your time in people, which gave you a different type of security.

Yes, I do define myself as African American. I really have never had a choice. As I said, my dad is disowned. No matter how light I may be, or how many times people may think that I may be Jewish or Italian, as soon as white folks find out that my mom is black, then I'm seen as black. Race is a political thing. It's membership in a caste. The other thing is that my family has been mixed for a long time—generally because of rape back on the plantation. Ultimately, the reason why I define myself this way is because I grew up around black people from my mom's side who looked like me.

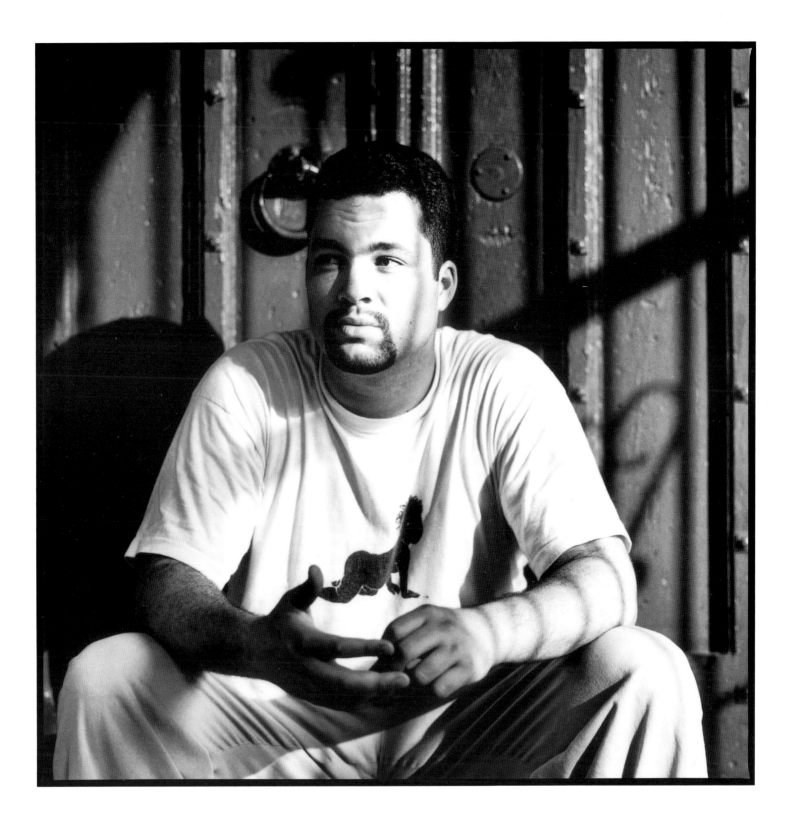

I had a lot of expectations going to Columbia, which is kind of notorious for hammering its students into the corporate mold. The thing that first hit me was all of the homeless people in the streets. So, one of the first things I did was spend a lot of time talking to them. They approached me on the street, and I, being a freshman, like them, was looking for someone to talk to.

I skipped over the Swarthmores and the Wesleyans and came to Columbia because it was in Harlem. Buildings in Harlem are warehoused in the sense that the landlords wait for the neighborhood to be gentrified so they can open their buildings back up. Two students who told me they had been working with a group called the Harlem Restoration Project called to say they wanted to organize a group of students to restore low-income housing in Harlem. Based on my outrage concerning all the homeless people, and the sadness I felt when I walked through Harlem, I jumped right into it. The two were seniors and flaked on the group. Three months later, the group had grown to 120 students. I had no experience in large-scale inner-city neighborhoods. I had no experience in restoring housing. I had no experience in dealing with Dominican people who didn't speak English. But, somehow, we did it.

Because there were kids in the apartment buildings we worked on—generally four of the five people living in an apartment would be under the age of eighteen—we decided to start a childcare program. The number of kids went from three to forty in a year. So the women and a few men did the childcare project, and I did the labor project. I raised money for both of them. We ended up expanding to two sights. Both programs are still going on today.

In December of 1992, I organized a protest in response to the university's announcement that they were going to tear down the Audubon Ballroom and replace it with a biogenetic research institute. We decided to block off an entire building where there were academic functions in progress. They brought in two hundred police. With two attorneys and their own general counsel, the administration swooped in to prosecute. They made some of the protest organizers get our own attorneys. The trial went on for six weeks. Finally, they suspended us for "aiding and abetting the obstruction of the entrance to the university for more than a short period of time."

I was burned out. I had always been a real good kid, but my school had labeled me a criminal. They had the FBI checking me out on campus. They had my phone tapped. They hired three lawyers to kick me out of school. It was really a lonely time for me. The univer-

sity decided they wanted to get rid of us and discredit us. I didn't know how to deal with that. So I kept taking on more and more responsibilities and, as a result, interacting with people less and less. I had been organizing without a break since I was sixteen years old and spent every summer in between organizing. I was exhausted and developed epilepsy from a lack of sleep.

I am a community organizer, so I believe that as an organizer my job is to help the community implement programs designed to address the needs they are concerned about. I have come back to the college and am working with some of the projects that I was involved with in the past. We're trying to raise money to turn an office into an independently funded ministry office, which means we will be able to bring in a left-wing minister who believes in multiculturalism and in student organizing. If not, the faculty, the administration, and the religious leaders are so conservative, that there will be no real institutional support for progressive students who are concerned about what's going on on-campus or how the campus interferes with life in Harlem.

Through the ministry, I've been working with kids here in Harlem. It has been great because they have really helped to ground me and just kind of keep me laughing.

Bruce Grady

Born September 18, 1967. **Bruce grew up in the church, and through that exposure, he has gained a sense of place and history as an African American. It is a role he feels the church should continue to play in black communities. As the minister of Beck Memorial Presbyterian Church in the Bronx, New York, and as an instructor of African American poetry at the Father's Heart Urban Prep School, he is doing his part. Bruce received a bachelor of science degree from North Carolina State, a masters of divinity from Duke University, and a masters of theology from Princeton Theological Seminary. He resides in Lawrenceville, New Jersey.**

I would say my undergraduate experience gave me awareness for the first time of what it meant to be an African American man. Once I went to college, I found out what racism was. In many ways being African American and male—but first being African American—in white institutions of higher education often meant justifying your presence.

Once at N.C. State I went to speak to a professor—he was actually a Ph.D. student—about an assignment. He didn't know me well except that I attended his class. I showed him what I had been doing, and I asked him for his assistance about solving the problem. Eventually, he told me that maybe I should spend less time on the basketball court and more time in preparation for the course. I was shocked because, for one, this man didn't know me, and two, I don't play basketball.

It was a threatening experience because I didn't want to believe that this could happen. A part of me didn't want to accept that this was the truth about the world. As a student, the trust I put into the hands of this professor was completely shattered, and it became an issue of power because I couldn't respond to him the way that I would respond to another student.

One of the benefits of attending Princeton, Duke, and North Carolina State was that I was able to meet other African American men and women like myself. We had a certain amount of commonality; we were able to talk about our situations and interpret each other. That exposure has given me a deeper breadth of knowledge about my culture and my identity.

During my childhood, our church reinforced my identity. It was a barn that had been turned into a church, and many of its stained-glass windows included the name of Grady in their descriptions. That fact gave me a sense of ownership, but it was not proprietary; I simply felt I belonged to this place. In addition, it was an AME church, African, Methodist, and Episcopal. It was an institution that raised my understanding of culture.

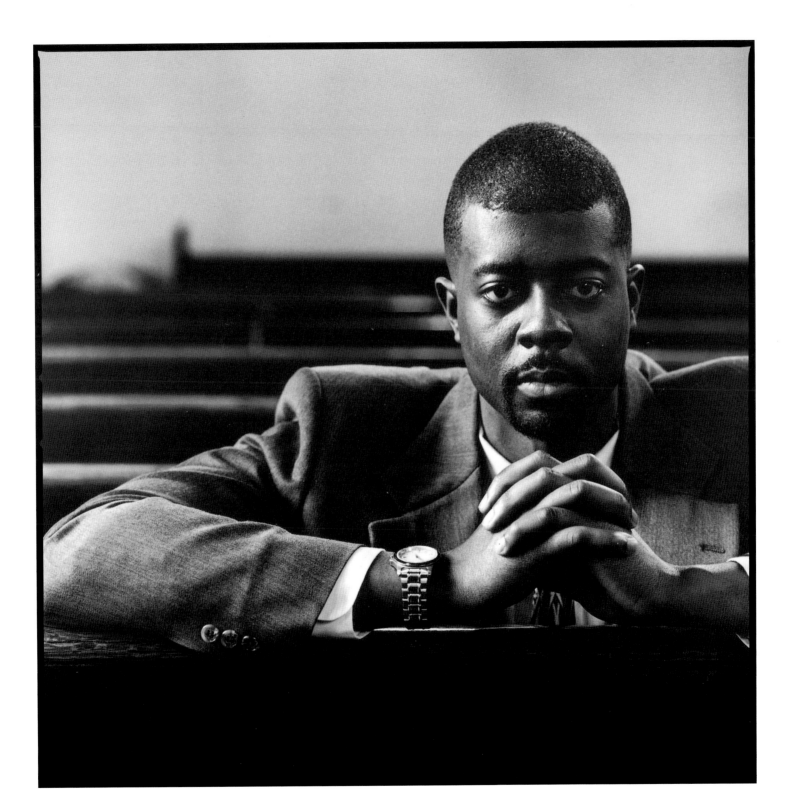

It was at church that I saw black people who owned businesses and people who were leaders in my school and community. When I look at the school system right now, I see that the biggest problem that needs to be dealt with among black youth, especially black boys, is nihilism. They don't have role models. The system is not as interested in youth as it should be, and because of the social misery and economic disadvantages of many black communities, many African American youth feel as if there is nothing that they can do that will change their situation. The attitude is, why bother?

I believe the church has, and must have, a role. It is a part of the charge of the church to uphold the humanity of all people. No church occurs void of a culture. Christianity always happens within the culture. For years the black church has been the cultural womb of the black community. Our historically African American colleges, many of our political advances, and several of our financial institutions have emerged out of the black church.

In America there has been a tendency for people to understand Christianity in terms of a white cultural context, although that is not what Christianity is. That is not the definition of being Christian, although in America for many years one of the dominant understandings of being Christian in the West meant being white. Liberation Theology, that is, interpreting the Bible and understanding God through the lens of your own culture, changed that for African American communities.

I am the descendant of people who were oppressed like no other people in the world, and yet they have overcome this. They have been the leaders of bringing peace into this world. They have been some of the most creative people in the midst of some of the most oppressive situations. They are people, although not the only ones, who have identified what it is to truly love one's neighbor. Who could have imagined that a descendant of people who had lived through three-hundred-plus years of legalized slavery would end up winning the Nobel Peace Prize? I am an heir to that history. I am proud to say that it has shaped me into feeling that no matter how hard things become, not only for me but for anyone, all things are possible.

I would say the constant threat a black man is interpreted to pose to the world is something that I have learned to understand. As a result, I am developing relationships with others to help explore how we can dispel the myth that perpetuates these poor images.

You can't make a person choose to accept you. One of the tendencies or temptations for a person like myself, who has been immersed in white America, is to assimilate or become more like his white brother or his white friends. I think that is a failure to one's self as a black man, to one's community, and to society. In doing so, you are denying who you are. To be yourself, to share yourself, and to be a testimonial of the great creation that God has made means to strive to use your gifts to the best of your ability.

My church and my family, including those outside of my nuclear family, were always saying to me that I was created for a special purpose and that God was going to use me. I believed it. As I hope to do for young people myself, they were able to identify certain things in me, and they convinced, or persuaded, me to expect those high values of myself. When you hear positive comments enough, and you have experiences to validate your ability, you just continue achieving. It no longer remains just their word; it becomes your story.

Derek Lassiter

Born November 8, 1965. **As a result of family circumstances and a series of foster homes, Derek had five different families by the age of eighteen. As a child, he faced daily fistfights in school, being labeled a troubled child, and the self-hatred born from family instability and being gay. Today, he is a singer, actor, poet, and publishing manager living in San Francisco, California. He currently performs with the band Ba–Lue, and he has acted in several productions, including James Baldwin's *The Amen Corner* at the Lorraine Hansberry Theater. His first book of poems, *Vision & Blindness*, was published in 1995. Not excluding other pursuits, he is finally an advertising production manager with Miller Freeman Publishing.**

In the summer of 1976 my sister, three brothers, and myself were told by our mother that she was sending us from the Bronx to Manessen, Pennsylvania, on a summer vacation to our grandmother's house. That was the last time I spoke with my mother.

The first night there was magic. It was probably the most beautiful night that I have ever spent in my life. It was summertime, and when we got to my grandmother's house we ate ham sandwiches and Breyer's vanilla ice cream. We went out into the night and saw lights blinking everywhere. The adults had to explain to us that those were lightning bugs, and we could catch them. We spent all night running around putting them into jars.

My grandmother and I had a tumultuous relationship, and in school I did badly. I was in fights every day because of people challenging me. If I fought one person, then I had to fight the next person. I hate fighting, but I had so much anger I would do it. Every day I hated going to school. My grandmother used to tell me that she would send me to a foster home if I continued the way I was going. She said that in foster homes you get up at four o'clock in the morning to pick beans in a field, where there are snakes hiding. I was terrified, but that terror had nothing over the terror of having to go to school and fight.

Eventually I was sent to a foster home. When the caseworker picked me up and drove me out into the country, I thought, "It's true. I am going to be up at four o'clock in the morning picking beans with snakes crawling around me." The family was white and had a nice house, but I had never been around so many white people in my life. I was the only black person in the town. There was a cornfield right out in the backyard, so I told them that I wasn't going out in that field if there were snakes. They said, "You don't have to go out in the field. Why would you think that?" In the following years, an additional two foster homes came and went. In my first eighteen years I had five different families, including my own.

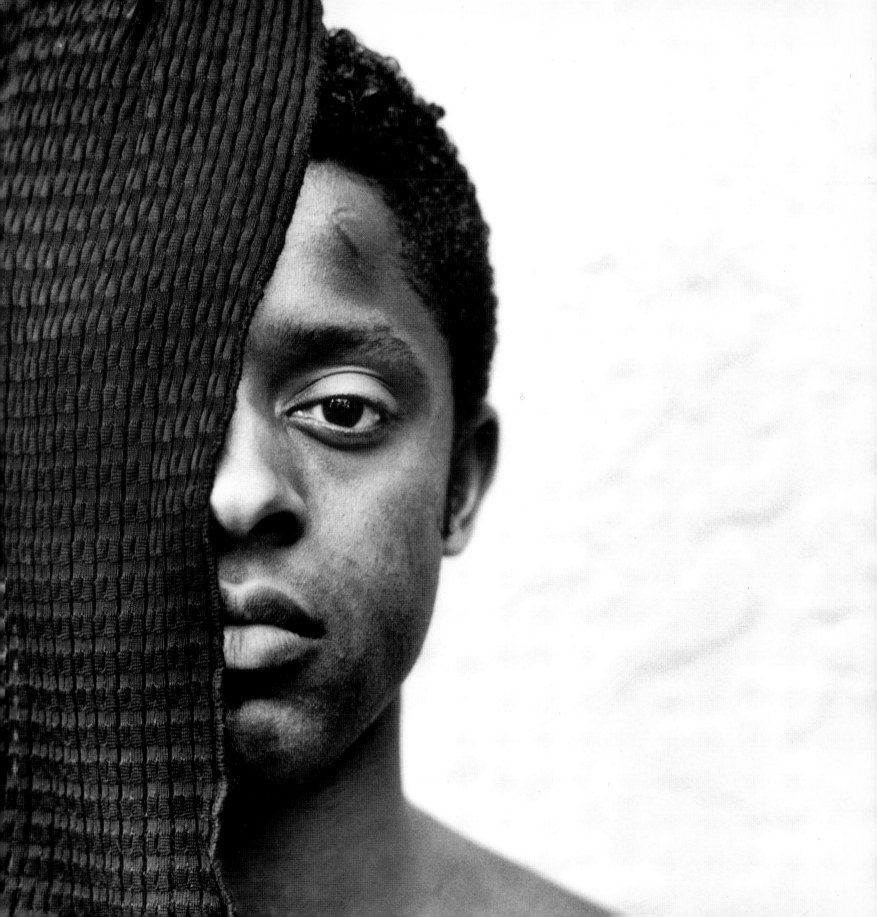

There isn't a day that goes by that I don't feel the loss of my mother. About two years ago I tried to contact her through the Social Security Office, but because of the Privacy Act they couldn't give me any information. I had to write a letter to her and allow them to forward it to her. After returning from a visit to Europe, I heard a short message on my voicemail at work. It was a woman and all she said was "Man" and then hung up. I assumed it was my mother because *Man* was my childhood nickname, and no one has called me that since I left New York. I have been reluctant to find out exactly where she is because I am a little afraid to know about her situation. In some of my poems, I have fictional conversations with my mother, and in one poem I told her how I was the first person to believe in myself. Because of that, the only person who can give up on me is myself. Once I do that, it's all over.

On top of all this stuff, I'm gay. So I have had to contend with that since childhood. There came a point where I was trying to fit that issue into the questions "Who am I?" and "What am I?" I would look in the mirror and hate my eyes, my nose, my lips, my everything. I thought nobody loved me, since my mother abandoned me, my grandmother hated me, and I had been in all of those different foster homes.

It was only when I came to San Francisco that I really started to grow as a person and as an artist. Being here is like being in a library. You can start your research once you get here.

Now, when I see children, all of my experiences make me zero in on personality. Personalities should be nurtured. Unfortunately, as adults we are always too quick to label a child as "problemed." In another poem, "Out There," I talk about looking inside for the weapons and the shields that it will take to survive out there. When we take those things away from a child, they have nothing to survive with except defensiveness. I think often it is too big an issue to say it's only racism that takes these things away. Racism may in fact be an issue, but that child must have his personality as much as possible because that is how he will approach each situation—with his shields and his weapons ready to dismantle or to build.

For a long time I just didn't have a role model, but at a certain point my aunt became the person in my life who filled that role. She was the first person that I looked up to.

Despite all that I went through, and for whatever reason, I didn't lose my personality completely. When I realized what it was, I started nurturing it. It's so funny, and it's not even about tricking yourself, but it all comes down to perspective. I look at myself now and I say, "Wow, I have an interesting nose. I love my nose. It's so weird. I have this little flat surface, and I can't imagine why I ever hated it."

Derek Smith

Born August 2, 1966. **Derek didn't have many successful black business-men to look up to when he was growing up, and as a result, he turned to the parents of his white friends. Derek has gleaned positive role models from any environment he has been in, and now that he has his own thriving construction company located in an economically depressed community, he feels as if it is his turn to help young African Americans. Derek started his first company when he was a junior at the University of Berkeley. He is now the president of the Marinship Construction Company. He resides with his wife, Renée, and their newborn son, Julien, in Oakland, California.**

I grew up in Marin City, a small, predominantly black city between Sausalito and Mill Valley in the Bay Area. We had wealth on each side. If you got caught doing wrong by so-and-so's mother, she would spank you until your own mom came to get you.

When I was growing up, they built condominiums on a nearby ridge, but they didn't call it Marin City. It's called Sausalito because the people who bought their townhouses there didn't want it to be known as Marin City. Today the two cities still share the same zip code. At the time, the only thing Marin City had was a sheriff's station and a liquor store.

A lot of my friend's parents from the private high school I went to were successful, and even though they were white, they were my role models. I didn't really grow up around a lot of successful black families, but the white families I was close to were very successful. Many of them were in real estate development, and I saw then it was something that I wanted to do.

When I became certified as a local business in San Francisco, a city official had to come out on a site visit. The office that he saw was my little room in the back of my grandmother's house, but he said, "Okay. You're ready to go." For my first job I didn't have any equipment, any bonding, any insurance, or any anything. I was scared out of my wits, so I called some friends who were contractors, and one suggested that I go in as a joint venture. After that, the company grew very fast.

I am not a shrewd businessman, but I am smart in the sense that I give a little bit to gain a hell of a lot. Some people say, "Why did you do that? Why did you give him that? He's using you." A lot of people say that I am too nice, and in some cases I have to check myself because I can't give too much. The biggest thing I've had to learn is how to say no.

There are some white contractors and developers who *are* using me, but at the same time I'm using them. In some cases, they're using me to satisfy goals and meet requirements in order

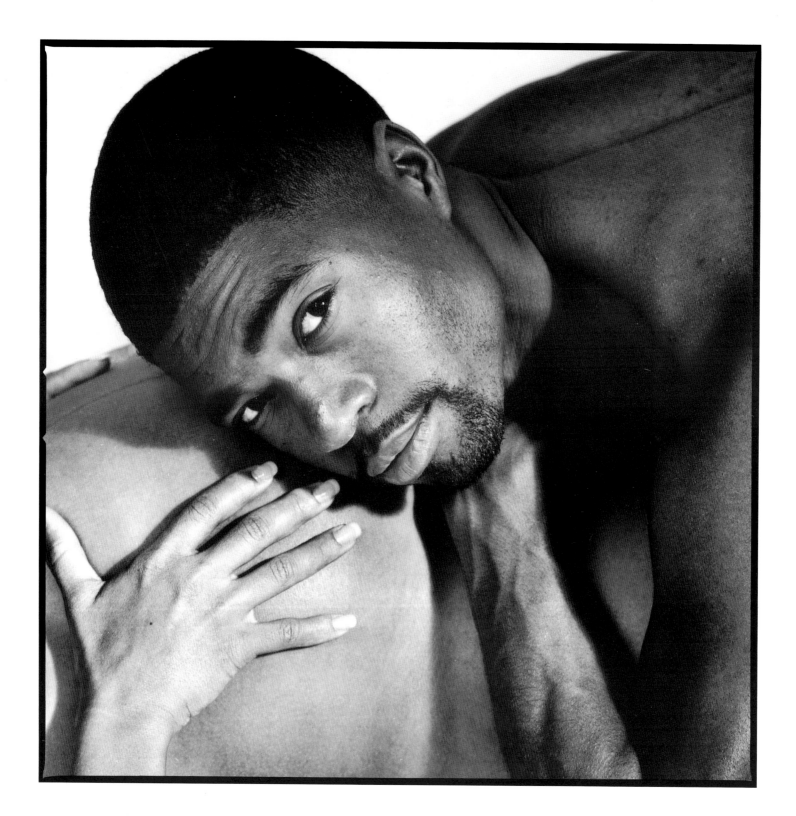

to get a contract. But if I didn't have any control in the situation, or if I had my hands tied behind my back, then I'd feel like they were using me. Instead, they're asking me to do work, and I tell them what I will do for a certain price. I'm getting work for the price that I command, and with it I'm gaining experience and developing relationships. I wouldn't have that opportunity if it weren't for them. If I were a white contractor, I wouldn't know half the stuff that I know. Because they have a genuine interest in me, I can go in and ask them how they run their company, or a certain aspect of their company, and they open doors.

I know the business, I can talk the business, and I know how the business is run. They deal with me as they deal with everyone else, on a professional level. Unfortunately, many minority contractors have their hands out with a "gimme this, gimme that" expectation.

One of the reasons why I have my office here in Bayview-Hunters Point, a predominantly black community, is to actively hire from within the community. I have brought a lot of kids into the unions and onto the payroll. Some of them worked out and some of them didn't, but I always dream about seeing a guy who's down on his luck but looking for an opportunity and be able to say to him, "Come work with me."

In the beginning I had some negative experiences in this business community. It was because I was a twenty-five-year-old kid just out of college who knew a lot of people. These older contractors—who had been in the business for years but were still struggling and working hard—resented the fact that I could come in and get all this work. They put me through a test of sorts by telling me I couldn't bid on certain work. Eventually, we worked it out, and now we occasionally do joint ventures together.

The most fascinating thing about construction is that you can drive by a project and say, "I built that," knowing that it will be there for a while. Not too many people, particularly a twenty-nine-year-old black guy, can say that they rebuilt Lombard Street, the most famous street in the world.

I am obsessed with being successful, but at the same time with being happy. I know too many people who are "successful" but miserable. The most important thing to me is enjoying life. I value the people around me. I have a lot of genuine friends who have been there for me. If—when, I should say—I have done well for myself and I look back at my accomplishments, I'm not going to be sitting up there on my high horse by myself with things around me. Giving people opportunities to work, or financing a friend's book project, that is my ideal.

There are many people who have taught me a lot. Although they are not expecting any-thing of me, I feel as if I owe them something. I owe it to them to be successful and to show them that what they instilled in me when I was young is paying off.

Over the course of my professional career, I have been exposed to a lot of successful blacks, whom I wish I would have seen when I was younger but I just didn't have access to them. Now, I have a lot of people whom I emulate and strive to be like. But back then, and growing up in a predominantly minority community, I didn't have those people around me. I just had athletes and people on television.

Although I feel a little pressure, the most important thing for me is providing for my family. I had always hoped to be already set up before I began a family, but it is here and it is going to work out. It makes me work a little harder. Now if I screw up it will affect two other people, but I am not really scared.

Devon Shepard

Born February 26, 1969. **Devon has gone from South Central to Hollywood; although it is only a short drive across town, the cultural disparities are significant. At an early age, Devon was aware of those differences, and today they inform his work as the executive story editor for the *Wayans Brothers Show*, a weekly comedy on the WB Television Network. He was previously a story editor for the *Fresh Prince of Bel Air* television show. An accomplished screenwriter, his latest screenplay, *The Come Up*, is scheduled for production by NewLine Cinema. He resides in Canoga Park, California.**

South Central was just called Los Angeles when I was growing up. I remember one night there was a shooting in Inglewood, but on television they called it South Central. Then later that night when the Los Angeles Lakers were playing the Boston Celtics in the Forum, they were calling it Inglewood again. When someone says South Central now, people think black, gangs, or something violent.

Growing up in Los Angeles prepares you for the realities of the world because you have to deal with things at such a young age. You rely more on common sense than on book sense. If you are born and raised in a box, all you are going to know is the box. If you don't peek over the wall every now and then, you aren't going to know what exists outside that box.

I went to Cal State Northridge, and even though it is only forty minutes away from where I lived, I remember thinking that it was just fly to watch squirrels run across the yard. Something as simple as a squirrel running was a blast for me because you don't see that in the hood. You see rats in the hood, but you ain't going to see no squirrels.

The thing I learned in college was that I had common sense, whereas a lot of other students didn't. I knew how to survive. The white kids in college liked my realism, my resourcefulness, and my drive. Where I grew up, if we didn't have money for something, we didn't worry it. We got over it and tried to figure out how we would get it tomorrow. It was like this: Today is here and if I ain't got no loot, that's that. I'm broke. What's the use sitting there and thinking about it? Because when you check your pockets two hours later guess what? You still broke.

I had a partial football scholarship, but I hurt my back and lost it. Then I found myself at a point where I didn't know what I was going to do. I started hustling on the streets, but for some reason, and to this day I don't know why, I just stopped. One day I woke up and

said that I didn't want to do it anymore. When I was a child my father was in the household, and he taught me things that a young man should know, like basic right from wrong. He made me get up at six in the morning to go and work with him. He had a liquor store, and there were days where he came home with some money and days when he would come home with nothing. I think my drive to succeed and my drive to stay away from hustling came from watching him struggle to get it done.

A man is someone who handles his business. Nothing more and nothing less. Whether you agree with his method is one thing, but a man is someone who handles his business and takes care of his own.

One of the gifts my father gave us is that he made us watch the news. I remember watching a *60 Minutes* report about black-on-black crime, where a sociologist did an experiment with rats in a large cage. Every rat had enough space to exist while he fed and watered them on a regular basis, and the rats lived in harmony. Every other month he would shorten the space and lessen the food. In the end the rats resorted to cannibalism and fought constantly. I was twelve years old and I remember thinking, "Why do we do the things we do?"

I think one problem with racism is that we try to deny that it is here. It's not as simple as saying we are all human and we all have to deal with the same situations. No, we all don't. As soon as we realize that, I think we can move on. It's like a drunk. A drunk is not going to sober up and go to an AA meeting if he doesn't think he's got a problem. He's going to keep drinking. America keeps drinking and refuses to admit that it's drunk.

An example of racism is that black television shows are not run by black people. When I was writing for *Fresh Prince*, a black show with a black star, there were twelve writers on the staff and only three of them were black. You do the math and tell me what's wrong with the picture.

What I have come to find out is that when black people go to the movies, they want to see as much realism as possible because there are so few of us on screen. So if a black guy says "Oh gosh" instead of, "Oh shit" when the situation allows, you are going to have a problem.

But when the *Fresh Prince* writers were pitching jokes for the next show, the three black writers would pitch what we knew black people were going to love. Then we had to sit there with the powers that be and explain to them why the joke was funny. The thing was, they would still say, "We don't get it." All we could say was, "Trust us." Nine times out of ten the audience would laugh.

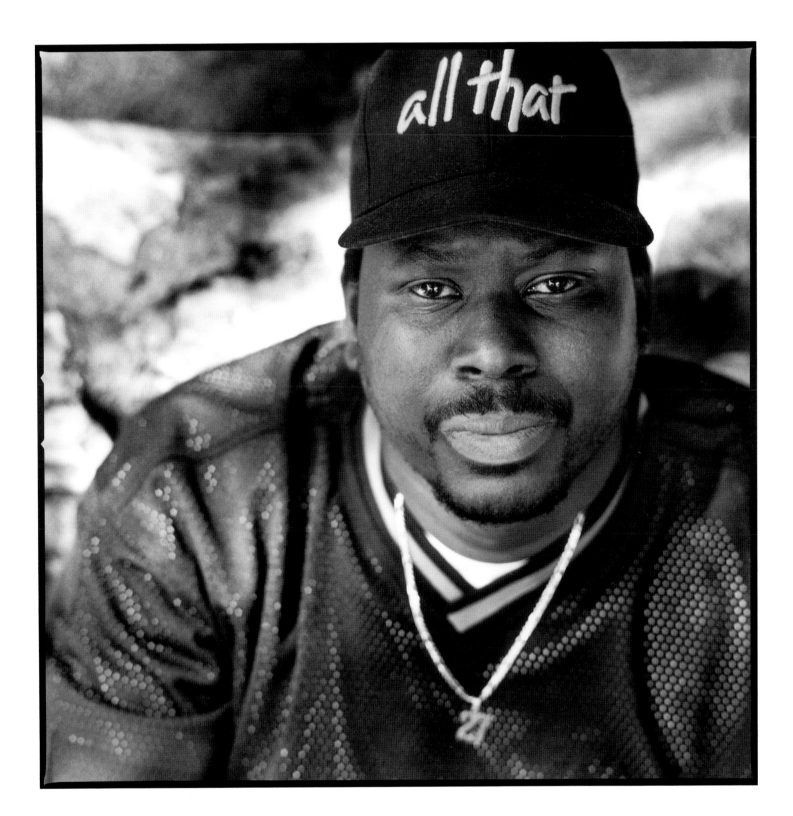

I don't think I am as funny as I could be. When you are hungry and funny, there is an energy that comes from the fact that you are starving. Things just come out of your mouth so fast that you have to hurry to write it down to remember it.

The producers of the *Wayans Brothers Show* love cross-over. We are told that white people are not going to get black jokes, but when you look at who goes to black films, it's white kids. White kids are dressing like black kids. White kids are more black than black kids.

I always hear that black people have attitude. Our attitude is our strength. We have seen, heard, and experienced things that other people don't experience on a day-to-day basis; our skin toughens just a little bit. It doesn't make us bad people. It just makes us able to deal with our environment.

Dexter Yarbrough

Born July 9, 1965. **Dexter is a plainclothes tactical officer with the Chicago Police Department. His assignments have taken him into the heart of Chicago's street gangs and drug dealers. In 1996, he was appointed by the Governor of Illinois to a six-year term as a trustee to Western Illinois University, his alma mater. He is the youngest appointee to any of the seven Illinois state universities and the only law enforcement officer. He resides with his wife, Patrese, and their two daughters, Dezaree and Maryssa, in Chicago, Illinois.**

When I was a child the neighborhood my family lived in experienced "white flight." Back in the sixties, middle-class blacks were starting to trickle into white communities, and my family was the second black family on the street. Within two years, the block went from 98 percent white to 98 percent black.

Now, my wife, children, and I live on the southwestern side of Chicago, a community similar to the one I grew up in. For years it was a totally white community. However, now you have younger middle-class blacks moving into the area, and whites are leaving quickly. Very quickly. I have been in this community for almost five years, and I see the "For Sale" signs going up and the moving trucks coming in.

The image of police departments across the country is at a low level. I think that a good majority of African American communities view the police suspiciously. On the other hand, the majority of white communities applaud the police. African Americans do not see the many sides of police officers. What they see is someone ordering them out of a car, someone being authoritative towards them, or someone not treating them with the respect they think they deserve.

I'm sorry to say that when I stop a car full of young black men, I start off at a higher level because I don't know what to expect. Somebody might jump out of the car with a gun or they may be college students. I don't know. But if it is a car full of white young men, I don't start off at that higher level. I'm not as intimidated, so I don't have to be as authoritative. My belief is that white people generally have more respect toward the police. That's because the police department has always been good for white communities.

I have seen the drug trade flourish from the time that I came on the force. I have watched kids—who were thirteen or fourteen years old when I first started—grow into really horrible young adults. I have seen those kids go to the penitentiary because they have shot and killed. Most of the time they have shot a rival gang member. It's awful because many

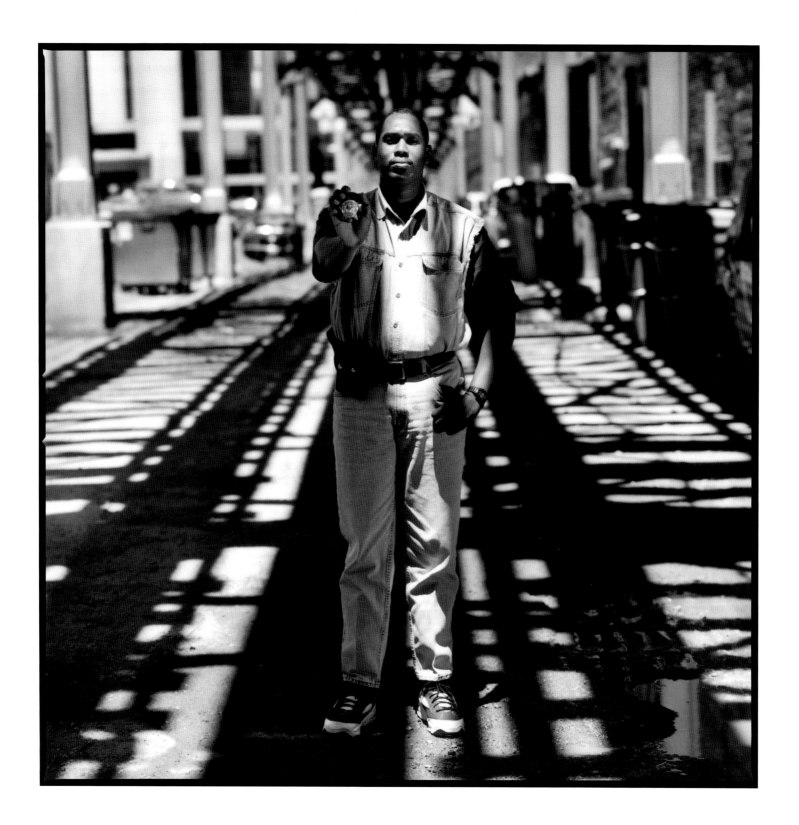

of them aren't bad kids. It's just that peer pressure and the communities they live in are full of criminal activity. They don't see any hope. They do what they feel is best for them in order to get what they want. They see a lot of drug dealers driving around in really nice cars and having all the money, and they aspire to that. For many of them it leads down a road of despair—the penitentiary or the cemetery. Unfortunately, the penal system is not really serving as a deterrent because the gangs are in control of a lot of what happens in the penitentiary.

Despite all this, I keep my strength by remembering that there are still more good people than bad people. I think the police departments and the communities need to join together to fight this criminal activity. A lot of these gang members come from families who don't realize their son is a gang member and is out on the corner selling drugs. When you bring it to their attention, they say, "No, not my child." They are just as much of the problem as the son because they have turned their backs to the problem. People can't do that, especially in the African American communities.

Now police officers live in some of these crime-ridden communities. So they are not just police officers, they are community people, too. Sometimes police officers look at citizens as "them" against "us," and we shouldn't. We should look at citizens as allies in this war against crime or gangs or drugs.

Sometimes I get stopped by suburban police officers, and I know why I am getting stopped. It is mostly because I am black and I am driving through a mostly white suburb. It is also, but less so, because I have a red car. Cops are known to stop red cars. Before I can show my badge and ID card, the police officer is at that high defensive level. It goes to show that first and foremost I am an African American male in American society. I may be a police officer, but until another police officer knows that, I am the same as many other African American males.

I don't become desensitized to all of the negativity because I have a life. Sometimes police officers get into policing, and they make it their lives. I have a wife and two kids. I am the member of the Western Illinois University board of trustees. I like computers and I like to shop. When I leave work, I leave it behind.

As an undergraduate, I went to Western Illinois University, where the majority of the population is white and from rural communities. Going there was a culture shock for me, since I had gone to a mostly African American elementary and high school. In college I had

two or three friends, and they were white. That first year I listened to white music, and my dinner partners were white.

It's probably because I denied myself to some degree, but I felt that people looked down on me for being black and for being from Chicago. So I decided to be with them. Then I was able to feel a bit elevated in their eyes. I wanted them to see that not all black people were alike. I guess I wanted acceptance from them. But then I started to get racist phone calls and threatening notes left on my door. The notes would say, "Niggers don't belong here," or they would be jokes of some sort. So I began to see another side of things, and that shocked me out of my cultural blindness.

After that, I started to get involved in the Black Student Association and black student groups and to mingle with black students more. I still kept my white friends, but racism brought me out of my shell. I started to find that if I didn't speak up for myself, no one would. I ran for president of the Black Student Association and won that election with the highest voter turnout of any other president since 1971. After I won that election, I realized that people had faith in me and cared about me. I was able to show myself that I could do good things and that I could be accepted by people. I was able to prove to myself that I could lead people properly.

Eric Coles

Born April 28, 1965. **In 1995, Eric's mother died of cancer and he lost his job with Sony Music, and these events led him to reevaluate his life. Combining his love of music with a desire to help other artists, he formed his own music consulting company, Colemine MusicWorks, which has been hired by MCA Records and GRP, among others, to find songs for various artists. Some of those artists he has assisted include Sade, Babyface, and George Benson. He resides in Brooklyn, New York.**

As a young boy, I went to a private school in New Jersey, where there were only a handful of black kids. Me and my two brothers were three of them. It was a culture shock when we moved to Florida, in that the other black kids thought we were too white, too proper, and talked too much like white people. I just thought that I was a little boy. For the most part, my friends were white because the black kids didn't relate to me, and I didn't relate to them. It wasn't until I moved to New York that I met other black people who were like me.

One summer, I left Fort Lauderdale to go to England, and I found myself in a city with many different types of people. That made me want to see every place around the globe as well as every place in this country. Just as with my alma mater, the University of Florida, I found that I learned more from the people I met than I did from my classes. I consider myself a student of life rather than a student of institutions.

Being in London gave me the insight that Americans tend to be conservative. The Londoners were really open, but the Americans I came across were not. At first, it seemed that all cultures lived harmoniously. As I got older I saw that wasn't necessarily the case, but it seemed as if people could live together and not have as many problems as they did here.

The year of 1995 was the worst year of my life. My boss at Sony Music and everyone he had hired, including myself, were fired. My mom passed away in May, and several other family members passed away shortly afterward. Since my mom had been sick with cancer for something like three years, I wasn't bitter that she had died. During the last year, she was in and out of the hospital almost every other month. I understood, and still understand, that she is now in a better place. I was mourning the loss of her in my life, not the loss of her life. I began to realize that I wanted to enjoy each moment to the fullest because it might be my last.

Getting fired from Sony turned out to be the best thing that could have happened to me. I felt like both my boss and myself had to put on battle gear before walking into the building

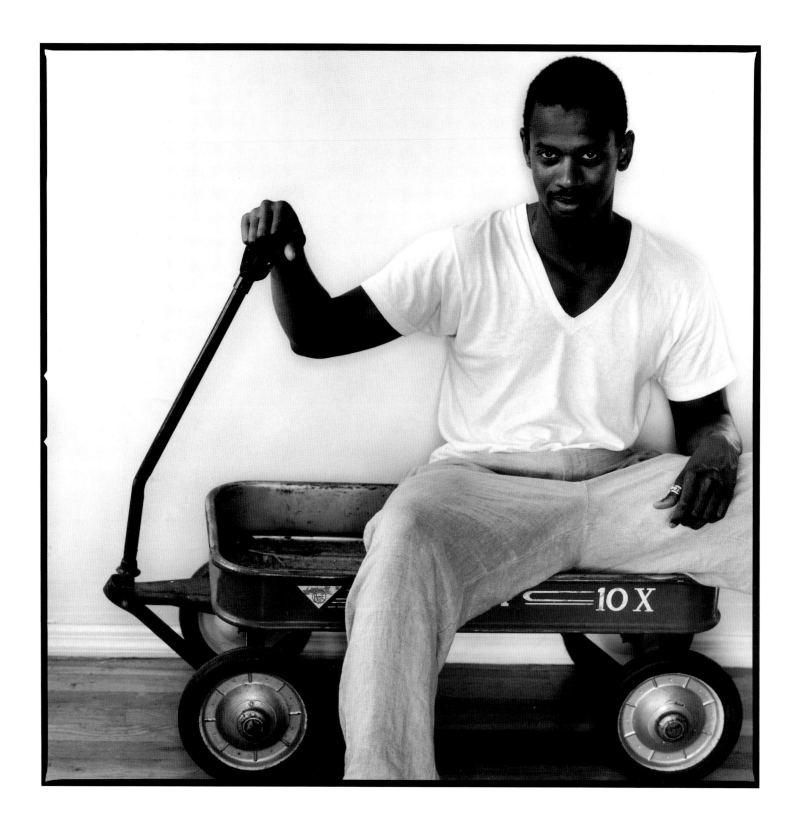

to perform our jobs. I had seen my parents miserable in their jobs, and in spite of the fact that those jobs put food on the table and clothes on my back, I realized that if I wasn't happy with something, then I shouldn't be doing it. My whole perspective on life has changed since my mother died. I realize what is important to me and what is not.

With that said, I am proud to say that I have helped young writers, producers, and artists, some of whom are from the ghetto, come to a better point in their lives. By giving them a record or a publishing deal, I have helped them realize their dream. But it's not just for the sake of helping someone. If I am passionate about what they do musically, I will go to any length to see their career come to fruition. I like music. That's why I am in this business. It certainly has its headaches, but if I was in it just for the money, I would go work on Wall Street.

One of those headaches is the responsibility issue. I don't believe a person is going to kill just because he has heard a song. On the other hand, if that trait is in you, then anything can flip you out and make you want to go shoot a cop, for example. Also, kids are easily influenced these days. I think people like Tupac, Snoop Doggy Dog, or any celebrity have a responsibility. The lyrics may reflect the artist's reality, but the artist has to realize that eight-, nine-, and ten-year-old kids are looking up to them as heroes. They have to be role models. I don't mean to say that they should start rapping about life in Bel Air, because that is not their reality. I don't want artists ever to be censored; they have the right to express themselves. If their reality is such that they go out every day and fight to stay alive, then fine, they have the right to rhyme about it, and the rhyme certainly has the right to be on a record. An eighteen-year-old boy has a mind of his own and should know better than to shoot someone. But an eight- or nine-year-old boy's mind is still being formed, and as icons, artists have to set an example. Any public figure who thrusts him- or herself willingly into the limelight must realize that people look up to them, and anyone who cannot take that responsibility should do something else.

I have an incredible amount of respect for someone who can write a song that moves me, or for someone who can open their voice and hit a note that sends chills up my body. So when I come across those people, and I happen to be in a position where I can help, I will.

It makes me feel good to walk out of my house and hear someone driving by in a Jeep pumping a song that I had something to do with. I know I am not changing the world, or performing brain surgery, but to some degree, it makes people feel better. If you are in a bad

mood, music has the ability to cure that mood. If I can in some way help uplift the masses and give them music that makes them feel a certain way, then I have been successful.

Throughout my day I can be calm and collected and not a lot fazes me. However, sometimes I wake up in the middle of the night in a sweat. I am tormented by not being as successful as I want to be, by the death of my mother, and by other things that may be going on. I can face those rough days only because I love life. I realize that my mom is in a better place. Although it's understandable, it doesn't really accomplish a whole lot to just mope around and not do anything because my mom is not here. Because of her death and all these other deaths in our family, I have become a lot closer with my family, but I still rely heavily on my friends.

People take the word *friend* too lightly and use it in many places where it doesn't apply. Maybe it is because I never had that sit down for dinner with mom, dad, the brothers, the sisters, and the dog type of life—mine wasn't the American family you see on television—but I have chosen to be around people who make me feel good. My whole take is that life should be fun. If it is not fun, then don't do it. Why make yourself miserable?

Eric Motley

Born December 17, 1972. **Eric was raised by his grandparents, who instilled in him self-discipline, a love for the church, and an expanded worldview. A young man of high moral integrity, he struggles to live his convictions each day, attempting to overcome racism through education and understanding. Eric is a senior at Samford University in Birmingham, Alabama. In 1995 he was elected its first African American student government president.**

My grandfather always tells me that I may not have the capacity to be a carpenter or an architect or to build homes and churches, but I can build other things that are eternal and long-lasting. I can build relationships with other people and between people, and relationships with greater things and nobler things.

My ancestors, who were early pioneers in the community, owned all the land on which we, and our neighbors, now live. My grandfather's sisters and brothers were brilliant in that they realized at an early age that land was extremely valuable, so they worked and were compensated with acreage.

My grandparents reared me, since my parents had moved to Atlanta to pursue their careers. Economically, my grandparents were better able to support my growth and my needs. I was bused to Dozier Elementary and spent a lot of time in a community Head Start program.

From the pulpit of our church, AME Zion, came messages of hope, active political participation and education; there was an awareness of what was going on around us. My grandparents were very religious people, and under no circumstances would we miss church. My grandmother was an assistant superintendent at the Sunday school. I think there have been only five times in my life that I have missed church, and in each of those five times I was either on a plane going somewhere or on a plane coming back. The regimen gave me discipline and commitment. It also allowed me to realize that there are greater things you have to commit yourself to.

My grandparents did not feel as if they had to explain things to me, but they would help me understand the reason why I was doing something. They told me that sometimes there were things I had to do for other people, and that at times it would be an inconvenience and a sacrifice, but that was what living was all about.

My Sunday school teacher had a large impact on my spiritual and social development. The church was concerned about the black people in Madison Park. At the same time, my grandparents taught me to care and love all people. So I began to develop this belief that my

community extended far beyond Madison Park. I never lost my sense of identity. I was constantly being reminded. It was constantly evident when I looked in the mirror, when I went to church, and when I went to after-school programs. Everyone was black. Those programs provided academic instruction: thirty minutes of algebra, twenty five minutes of reading, five minutes of memorizing the Ten Commandments, and twenty-five minutes of memorizing the poetry of James Weldon Johnson and reciting works by James Baldwin.

That is where I really came to know myself as a black person, a black student, and as a black person in a white-dominated world. I will never forget one teacher reminding us that we were citizens, too, and we couldn't complain unless we took action and played an active role in being informed. I came to conclude that as a Christian I had a larger commitment to the community that superseded the Motley house, Madison Park, and the black community.

I realize that there are many injustices that we face as black people, but I also realize that we have to live in a world with many different people. As we strive to improve conditions for the black community, we must also look at ways to improve conditions for all people who are facing injustice. I really do believe that one of our missions should be to educate people and help people better understand each other.

The black population at Samford University, a Christian university, is 4½ percent of the student population. Prior to my election, there had never been a black student body president. I was the first black student to be homecoming king. I have helped many of the alumni accept that the community is changing. I have been a wake-up call to a lot of people in this small Christian community. I find myself continuously helping people make a mental paradigm shift. Some of my classmates came to Samford without ever having had an interaction with a black student. So I realize that some of them are victims of their family's ideologies and victims of the communities in which they were reared.

As a black student, I have always been cautious about how I respond to any circumstance, because, in no way, do I want to encourage the stereotypes and myths that are out there. I don't feel pressure, though, because I see myself as *the great integrator*. St. Francis of Assisi wrote, "Help me to understand, more so than to be understood." I seek to understand, and that is my entire message.

The older I become the harder it is to maintain that strength to understand. I am able to because of the discipline my grandparents instilled in me. As a child, not only did I have to do my chores and have them done at a certain time, but also everybody was up at five o'clock in

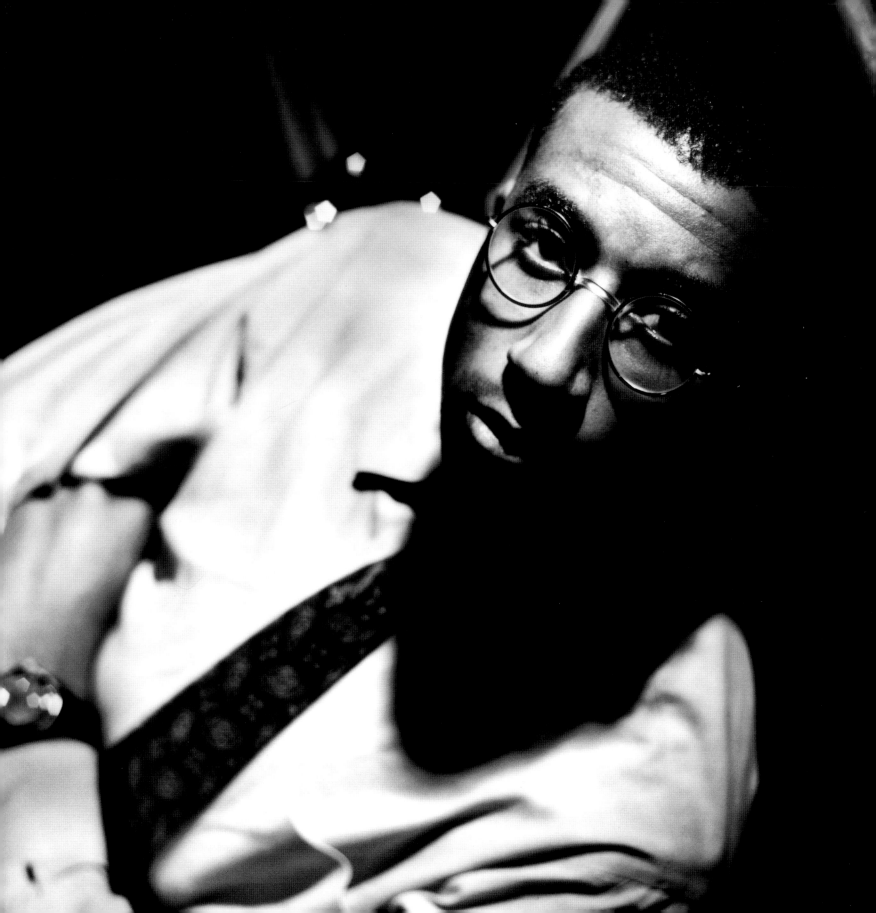

the morning. My grandmother got up at four and she had breakfast ready at five. There was no sleeping to 5:05. My family had hot tea three times a day together. It was all discipline.

Part of that discipline involves trying to better integrate my political, social, and religious beliefs and to ensure that all three are consistent. Well, some white students were trying to do the same and invited me to integrate their fraternity. They challenged me to look at my message of understanding others. There were only three blacks in the United States to ever be a part of this fraternity nationally, and never had such an integration taken place at Samford.

Partly because I had no desire to be in a fraternity, I struggled over the decision. Ultimately, both black and white students put my life under the microscope. I pledged with the fraternity, and I can't tell you how much hesitation I had about it. I got the bid and expected a lot of opposition from my black classmates on campus, but all I got from them was encouragement. One white student whom I had convinced to break away from his parent's rudimentary way of thinking, and to think for himself, later had the audacity to tell me what his parents, and other parents, were saying. They were saying, "He is a great guy, and he has done so much for the university, but he is crossing the line with the social thing."

I am convinced that the people we have to educate most in society are the Christian people. They are the ones who think they are on the right path, and it's so hard to convince them when they are not. I received one or two anonymous phone calls, but never did I get a call saying, "Nigger, don't do this." One was from a parent who said that she and her husband had taught their child to love all people, but they had also told their child never to become close to black people. She went on to say that I really challenged their daughter as well as their entire family to go through a soul-searching experience.

I would have to say that I am a transformational leader. I encourage those whom I interact with to become learners and to realize that learning is a continuous process. I am continually trying to learn about, and from, others, and I am constantly trying to get others together so that they might learn from each other.

Fazal Sheikh

Born June 27, 1965. **Fazal is an internationally known photographer whose work has taken him from Nepal to Rwanda. Although he does not subscribe to racial classifications, and his features are not typically African American—his Kenyan father is of Pakistani descent and his mother was a white American—his connection to the African continent is nothing less than inspirational. Fazal graduated from Princeton University in 1987. His photographic awards include the Leica Medal of Excellence, the Infinity Award from the International Center of Photography, and a Fullbright Fellowship in the Arts. He is represented by Pace Wildenstein Macgill Gallery and has had numerous exhibitions. Permanent collections of his work are on display at the National Museum of Kenya and the San Francisco Museum of Modern Art, among others. His latest book, *Fazal Sheikh: A Sense of Common Ground*, was published in 1996. He resides in Princeton, New Jersey.**

One of the wonderful things about growing up in New York is the sense that everyone belongs and has something to offer. But the cosmopolitan nature of New York also has a way of sheltering you against a lot of things. My first experiences with racism were not in New York but in South Africa and in the South here in this country. In South Africa I was this odd mix. Until I proved myself, I was not accepted by the whites, the coloreds, or the blacks. Because I spoke English and because of my skin color, I had no chance in the Orange Free State, the Afrikaaner homeland.

My father's father came from what is now Pakistan, but my father was born and raised in Nairobi, Kenya. I would say that he identifies with being Kenyan first, although he was this displaced character throughout his developing years. My mother was a WASP from New Jersey.

Although I grew up in New York, I spent my summers in Kenya with my father's extended family, and in many ways Kenya has the most racist communities I have ever lived in. The legacy of the white colonial era still remains. There are Indians, Africans and whites, with a great deal of oppression being directed toward the Indians, who in turn displace it on Africans. The Africans, themselves, had their own tribal tensions between the different groups. I went to Kenya for my most recent book as a means of inquiry into my own community there and also as a way of turning outward and looking at the rift between media and imagery around the world.

Because I have experienced all of those different groups within myself, I am also an odd mix. That may be why I don't consider the issue of color when I see people. I don't see what

their makeup is and then conclude that if they are of this group, then they will have a specific understanding of the world. I don't see connections based on culture or skin type. The nice thing about possessing heritage from both sides is that it forces me to be more compromising and more accepting of different perspectives. I don't like the exclusionary element of racial classifications. Somehow it is like being part of a club. Strictly speaking, I am possibly more African American than anybody in this book, yet I think many people would want to exclude me from that clique—thinking that it's a movement that needs to be focused on one group in an attempt to make up for a skewed history.

Since I have been privileged enough not to have to deal with that degree of racism on a day-to-day basis, I can understand that focus. I am not sure whether it is because I was among the privileged or because my art somehow made me acceptable. For whatever reasons, it seems that if you have something to offer, then that thing will validate you.

I never felt that I should be afraid of a person because of their color. That is also the way that I work in the refugee camps. I don't have the sense that there is something to fear in a given community. Most recently, when I was going to the Rwandan refugee camps, one of the aid workers asked me, "You're not going to go work in the camps with murderers?" I looked at the guy astounded, thinking how on earth did he come to work in a place like this when he had that kind of perspective, believing that three hundred thousand people were responsible for the atrocities—yes, heinous—but yet atrocities committed by a small fraction of the people. I would much rather be trusting and approach a group of people in an open manner than be wary and suffer whatever the consequences are.

In 1987, my mother committed suicide, and while my extended family was rebounding from that, my grandmother became ill. It was odd to see the psychological effects it had on the family and how the different tensions were played out. Maybe because I was a generation removed or just because of my personality, I was more inclined to confront those tensions head on. So I became my grandmother's main caretaker. Through that, I was able to learn about my mother's childhood and dwell on what had happened in order to work through my feelings about her suicide. It also allowed my grandmother to let go of her misgivings as a parent. So in that way, dealing with those tensions became a blessing.

My mother had been very influential to me. The way I approach life is informed by my having grown up with her. She was obsessed about art, museums and writing and all of that rubbed off on me.

Two people whom I respect a great deal, Toshiko Takaezu, a sculptor, and Emmet Gowin, a photographer, taught me that if I made my life consistent with my work and I remained true to that connection, all of the opinions, the hype, the ups and downs of the art world, wouldn't have much of an effect on me. If you see Emmet's work and then you meet him, you will know that the images are really a product of who he is. It is so funny. Even when you hear photographers speak, they have a rap about their work that is not being expressed in the images. In fact, what you see in pictures is the artist's personality, and that may be that they have a certain reserve or sarcastic take on life. It's amazing how that works.

It took me a long time to learn that the strength of a body of work comes not from going to a place and capturing what your imagination has already conjured up. It comes from giving over the control and acknowledging that this amazing thing has been given to you. The trick is to acknowledge what is truly amazing and not to imagine it before it happens. Nothing I can imagine before going to a place can ever be as strong as something that comes from my connection to it or my collaboration with it.

Photography has always been a kind of inquiry for me. It is a way to work through my emotions and a way to gain a better understanding of the world. The best thing I ever did was to have faith in my ability to create and faith in the process. Even when we were just speaking about my mother now, I remembered that I had worked through that to a certain degree in my work. Photography has the ability to become therapeutic, and once you get through that early nervousness over your commitment to making art, it gives a great deal back.

Cleo Fields

Born November 22, 1962. **Cleo grew up in rural poverty, but, inspired by his mother, he rejected the stigmatizing labels of his school system, which would have had him believe he was less than other students. Today, as a member of Congress, one of his goals is to eliminate that entire system of labeling. Cleo was elected to the Louisiana State Senate at the age of twenty-four, the youngest in the state's history and the youngest in the nation at that time. He began his first term in United States Congress in 1992. At the age of thirty, Congressman Fields became the youngest member of the 103rd Congress. He resides with his wife, Debra, and their son, Brandon, in Washington, D.C.**

I was born the seventh of ten children in Baton Rouge, Louisiana. We were a very poor family living on the rough side of the road. When I was about four or five years old my father died. My mother gave us a lot of inspiration by teaching us to dream that we could be everything and anything. She has always been my role model. I saw a woman who woke up, dressed us, put us on a school bus, went to work, cooked and washed at her job with somebody else's children, then came home and did the same with her own family. That was monumental. If I could be half as great as my mother, who never finished college, then I would consider myself a great person.

I didn't know that I was poor until I got to junior high school. When I was growing up we had holes in the bottom of our shoes. *Name brand* was whatever brand was on the jeans— if we even had names on our jeans. We took baths in the foot tub. We ran a hose through the kitchen window and filled it halfway with cold water, and Momma would put pots on the stove to boil water. We would mix the hot water with the cold water and take a bath. My mom couldn't afford twenty-five cents for me to go on a field trip. But we went to the library instead. I wonder who I would be today if I did not have those past experiences. I think the greatest thing that ever happened to me was that I grew up poor.

Life as a child was tough but fun. Fun because it would have been very depressing if we dwelled on what we didn't have. Mom would always tell us not to worry about what we didn't have but to use what God gave us. God gave us a family. God gave us a house of impunity.

I think we have to stop talking about poverty in this country. I know that we have economic problems. I certainly don't have the attitude, "I've got mine, now you get yours." But, instead, "Thank God that I got mine because now I'm going to see to it that you get yours."

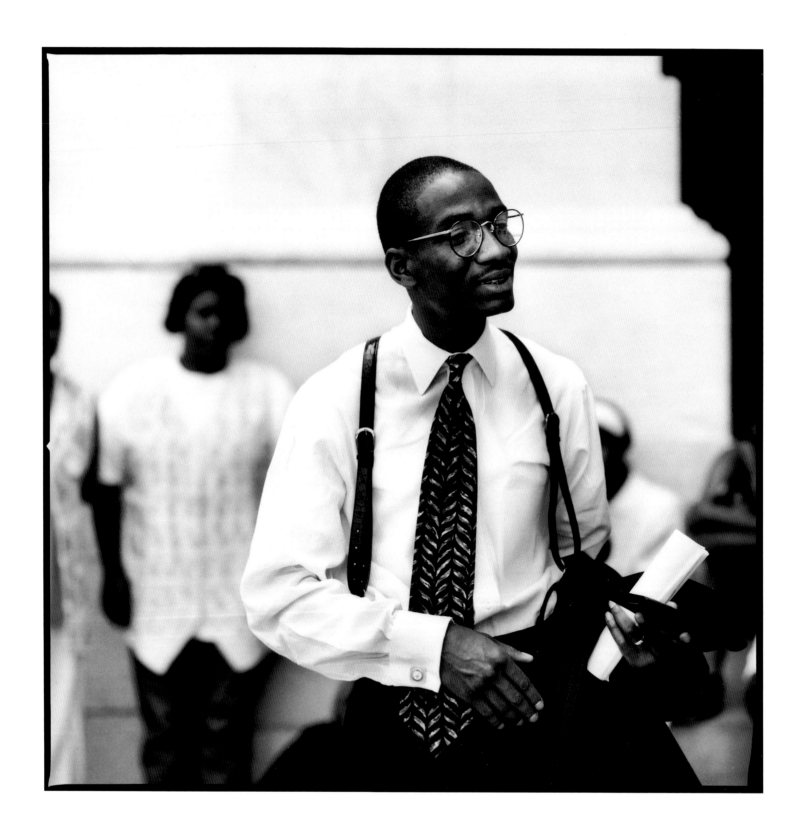

I got it through no other reason than prayer and the help of a lot of faceless people, whose names will never be published in any publication and will never be read in any newscast. All flowers don't bloom at the same time. But I do think that we've got to stop talking about our circumstances. If we sat around the room and talked about how bad off we were, we would have been spending so much time doing that, that we wouldn't have had time to do other things.

I was called "at risk," "disadvantaged," and "underprivileged"—three terms that I'm fighting to get rid of as a member of Congress. When we stigmatize children because of their circumstances, then we mess with their self-esteem. Here I was making As and Bs in class, then all of a sudden I'm separated from the rest of the class with ten other students and classified as "at risk," disadvantaged," and "underprivileged." Mom said to me, "They're talking about your income, but you can't let that determine your outcome. Because your mind is not disadvantaged. Your mind is not at risk, and your mind is not underprivileged."

We, as a society, have a way of giving people tricks. They gave me my role. But I didn't play it. They've already appropriated special funding for black youth. There are a lot of folks here in Washington who have already written the script for them. They're already saying that most black males will not live beyond the age of so and so. The hell with being at risk, disadvantaged, and underprivileged. What does it do to that person? They start accepting it. We ought not to label people. And if we label people, we should label them for academic reasons but never for economic reasons. Because then we'll have the "haves" and the "have-nots."

When I was twenty-three, I got into public life by running for state senate. We registered thousands of young people and for the first time in their lives they were registered to vote. The Southern University campus, where I was a student, was always a bloc vote. Everybody just felt that students were apathetic about voting. They weren't apathetic, they just weren't inspired. Everybody said, "You should run for city council or the school board. That's the way it's done. You don't run for the state senate as your first elected office." But you know, there's no requirement that you have to serve in local government before you turn to state government.

When I was elected to the state senate, I was a little kid. I put on the best suit I had and my little polyester tie, and I went to the state senate and took my seat. And this state senator walked up to me and said, "Excuse me, son. Can you get me a cup of coffee? You must be a page. You're working for the senate, right?" I said, "I'm not a page. I'm a lawyer. But when you see a page, you tell him to get two cups of coffee."

I don't need to be a part of what people say or what they think. I have a job to do. When I said, "Don't burn the bridge because you might have to cross it again," my mother got so upset. She said, "Boy, that is so selfish. You don't burn the bridge behind you because you want to leave it there for someone else to cross." That's the attitude that we've got to have.

I demand respect. Is disrespect not speaking to me? That's fine. Is disrespect not liking me? That's fine. You don't have to like me. When I get to the floor of the House of Representatives, just like all the other members of Congress, I have a voting card. This is the ultimate respect for me. As long as the people give me the power to walk in there and vote, that's all the respect that I need.

Lowell Gibbs

Born June 7, 1963. **Lowell is in a position to experience prejudice twice over, as a black man and as a gay man. As a member of the board of governors to the Human Rights Campaign Fund, and through volunteer speaking engagements, he is politically active in the gay community, working to dispel myths about homosexuality. He is an investment banker and currently a vice president of a San Francisco investment management firm. He resides in Oakland, California.**

I knew that I was not like the white kids. And they knew that I wasn't. But it wasn't an issue of "Well, you're different, therefore we're not going to invite you over." It wasn't an issue intended to be divisive. I knew racism existed; I knew what it involved. But it wasn't something that impacted me on a day-to-day basis because I didn't see it.

However, you are sometimes rudely reminded that, in fact, your presence may change the dynamic. For example, recently we were at a meeting in a client's boardroom and during a break we talked about how we got into the city. We had taken MARTA, Metropolitan Atlanta Rapid Transit Authority. So, this good ol' boy, with a deep southern accent, says, "It's known by another name also." I had been sitting across from this man for three hours. He looks up and then says, "Oh, just forget about it." What he was going to say is "Moving Africans Rapidly Through Atlanta."

It reminded me of the function of *presence*. I have sat in meetings where if no woman was present, men would make sexist comments. It reminds me that people are still backward, ignorant, and stupid. Before the break, that good ol' boy had seen me as a corporate banker, just like the rest of them. He saw me as one of those Ivy Leaguers. It's interesting, but I am often dealt with on that basis, rather than, as might otherwise happen, on the basis of what they consider to be a black man. The treatment levels are much different. It makes me think that if I get treated badly sometimes, what must they do to everybody else?

My mom has always had the perspective that I am, first and foremost, a black male, because that is the way that people see me. That is true. However, it is an issue of tension between us because most of my friends are white. I grew up in a community that is very white in terms of values—superficial values, really—i.e., music, fashion, Madras shorts, J. Crew T-shirts. But that was the culture in which I was raised, and it's the culture in which I am comfortable. Which doesn't mean that I'm not aware that I am black. Because I am. I am aware of how it can both hinder and help me.

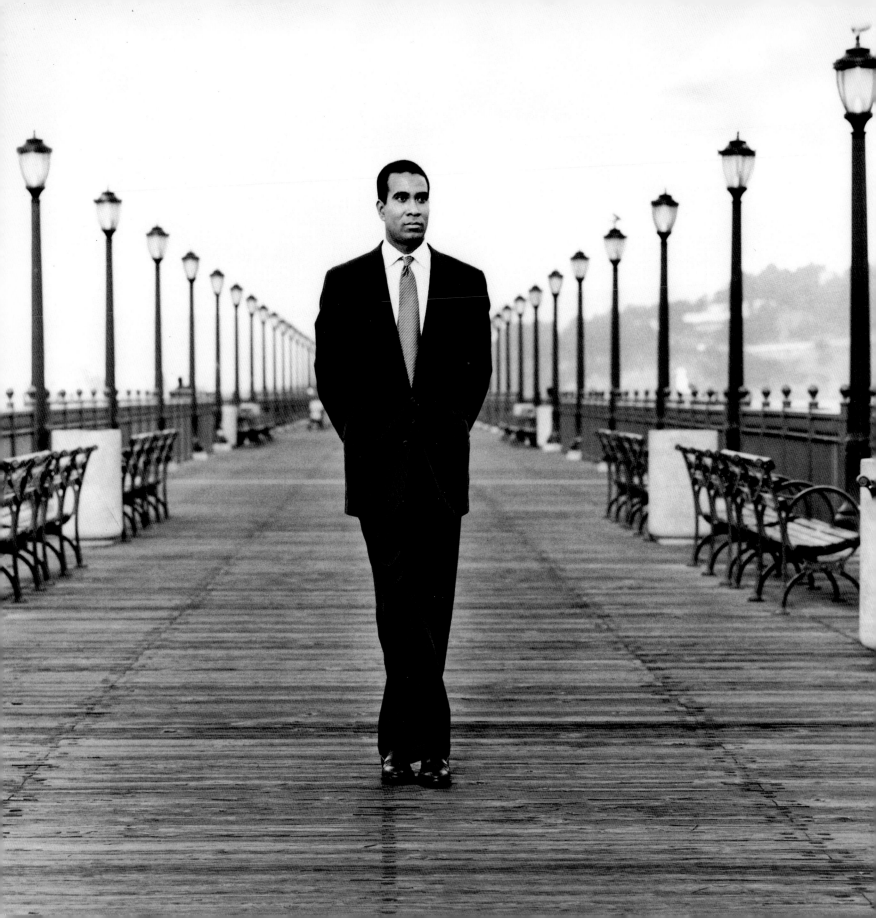

I don't think your identity is strictly a function of what color you are. I have cousins who are white. Our grandmothers are sisters. One is black and the other *passed* and grew up as white. So now, there is a black branch and a white branch in the family. Believe it or not, they came together on *Oprah*. But my second cousin, Jeff, is thirty-eight years old, and if we were to take a test, he would score as black-identified much more than I would. He could tell you every rapper who's in the Top Ten this month and who was in the Top Ten last month, what the kids in the hood are wearing, and why they're wearing it. Even though Jeff and I share genetic background, the world perceives him as a six-foot-two, half-Italian male, and they see me as a six-foot-four, black male. But I don't think one's identity is an issue of color. It's an issue of understanding how you interact with the world and how it perceives you. That's what should define you.

I had no internal trauma over being gay, and I had very little external trauma over it. There are a lot of people who go through it to the point of suicide. It's partially because of the household that I grew up in. There wasn't this constant venting of hatred toward homosexuals. It's also because there was always a recognition that it was okay for a man to think another man was good looking.

I volunteer for Community United Against Violence, referred to as CUAV. Their mission is to help gay and lesbian victims who are subject to anti-gay and lesbian violence. CUAV has a speakers bureau, which primarily speaks to high school students in San Francisco as part of their basic sex-education class. A gay man and a lesbian go in to discuss being gay.

Part of the reason why we go is to dispel myths. The students have very strong notions about people who are gay, and they are usually very focused, very narrow, and very wrong. They think being gay means X, Y, or Z. And that X, Y, or Z is that we all wear dresses. Or we all have AIDS. Or none of us are Christians because if we were Christian, we couldn't be homosexual. Or we all get the same haircut. Or we all flaunt it.

Their exposure to gay peers is usually zero. One of the biggest misconceptions is that all gay guys like to dress up in dresses and in drag. Or that we all want to be women. We want to be factual when addressing the group. For instance, we say that 95 percent of cross-dressers or transvestites are heterosexual. The difference is that they don't have gay day, so you don't see one hundred or three hundred of them out on the street.

That's the type of information that would never be disseminated through standard channels because the heterosexual community would be loath to actually admit that. And what is

this thing called *the homosexual lifestyle*? If reading the paper is any indication of what *the heterosexual lifestyle* is like—with domestic violence, infidelity, and molestation—then I don't know if *that's* a lifestyle that should be promoted and considered decent. Yet, everything that we do is put in this context of *the homosexual lifestyle*. It's not a lifestyle, first of all, it's a life. A lifestyle is making a choice about becoming a "Deadhead." Something that is fundamental to your existence, like your sexuality, is not a lifestyle.

I enjoy the opportunity to educate through example or via a seminar. I get very involved in the political side because, unfortunately, the people who hate us are really interested in our destruction. We could be apathetic, but if we were apathetic, we'd run into even more problems than we do today.

I am committed because I have the opportunity to be. I have the ability to be. A lot of things are luck. It's partially lucky that I was allowed to have a job that gives me some disposable income. There was some hard work involved, but a lot of it is luck. Some people want to do things that are hands on and people related. I like to do things that have that same element but are political in nature, educational in nature, or activist in nature.

Ikolo Griffin

Born July 6, 1974. **Ikolo, a dancer, is descended from an African prince, but since another ancestor was an American Indian and his mother is white and Jewish, his sense of identity is complex. In addition, he grew up in a house dominated by his Japanese stepfather. Today, Ikolo is a member of the Corps de Ballet with the San Francisco Ballet. He is the first student from the Dance in Schools Program to receive an apprenticeship with the ballet. Ikolo means "the greatest drum." He resides in San Francisco, California.**

I was one of the first black dancers to dance the role of the Nutcracker Prince here in San Francisco. Ballet has always been associated as being a white thing, a Caucasian thing. It's the body-look thing. Ever since I started dancing at the age of eight, I have thought, "Okay. I can dance. But can I really dance? Can I have the look?" My dynamics didn't look like everybody else's, so I thought that I was wrong. Only a month ago I thought, "It looks good on me. Just because I don't have the same body that they do, I can still do it. And I can do it better." So my style has been slowly coming out. However, it is not going to be the same style that they're used to looking at.

When I went to the eighth level at the San Francisco Ballet School, the teacher kind of ripped on me. I didn't get direction from him. I don't know whether that was prejudice, or what, but I was offended. Maybe it was my first real experience with racism and prejudice, I don't know. You have to remember that I grew up with a Japanese stepfather, a white, Jewish mother, and a brother and a sister who are lighter than me, since they are Asian. I felt happy about the mix in our family. I thought that was natural. I didn't really know what racism was.

But for a long time ballet was a refuge from having to go home and do chores, be disciplined, be on your best behavior, and be real formal. There was just a lot of tension at home. Ballet was a great release. I could work out my own personal things. I could get away. It was almost like a savior coming into a chaotic house.

Basically, I didn't grow up with any black influence and I didn't have many black friends. So, relating to black people was very difficult for me because they looked upon me with different eyes. You could say that I speak in a white tone, which leads people to say that I am eloquent, but I don't know how I feel about that. Sure I'm eloquent, but is it just because when I speak I don't say "Y'all?" Because I was being labeled as different, I started to think I was different. But it was a combination of two things. Black people would look at me differently, and I would look at them differently. I wondered whether they would accept me.

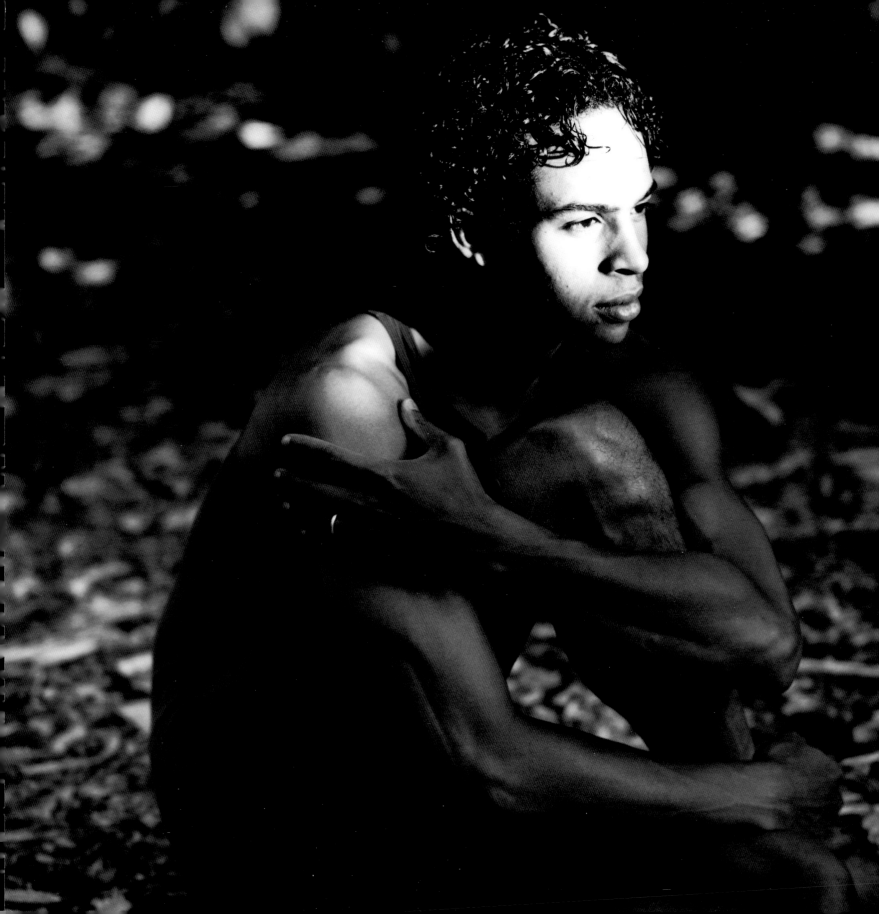

Now, I'm learning about the culture by watching my biological dad and seeing how he defines himself as a man. I see him as wise. He is like a shaman or a priest.

He told me a very interesting story about our family. But being the storyteller, he can change things. There is me, my father, my grandfather, my great-grandfather, and my great-great-grandfather. The first one, Nace, came from Africa somewhere. The story is that he was a prince and a slave trader. He was taking a shipment of thirteen slaves. He was told that it was supposed to be fourteen slaves. So he got taken on the ship. He survived the trip and was sold to a lady in the Carolinas. General Sherman had just broken through the Confederate lines and was coming through and burning all the plantations and houses. The woman was alone, since her husband had left for the war. Nace went up to her and said, "Let me take you away from this." They went off into the swamps and survived. A posse went after them. The posse never returned. The son of Nace left the swamp, intermingled with a Carib Indian, and had my grandfather. Then came my father, then me.

When my father told me that story, it completely changed me. I hold that story so dear. I think it affects my thinking by stopping me from doing the wrong things. At any point in my life I could have gone astray. I could have quit ballet. I could have gotten into drugs, stolen cars, or joined a gang. Drug dealers were just up the street and around the corner from my house. But I feel as if that story is the one thing that saved me. It makes me feel special, as if I am a prince among men.

The thing about the medium of dance is that it's universal. And it's not only universal, it's traditional. It is one of the first forms of communication. It is one of the first forms of expression. That is exciting to me. One thing that I want to do is find the point in dance that relates our past to our present. Because then, how could someone watch and not understand?

I have dedicated my life to dance. I'm doing something that I love to do, something that I have been doing for a long time. I'm not struggling with anything, and I've got lots of love in my life. That totally outweighs all the negativity that could possibly happen. I have lived beautifully, and gracefully, and as a prince. That is something that pushes me when I perform. On stage, I feel very comfortable, very at home, and very at peace.

Eric Johnson

Born January 13, 1968. **When Eric was growing up, he didn't fit in, not in the black neighborhood where he lived nor in the white grade school he attended. Today, he is concerned about preserving the history of African Americans, and he is developing a collection of fine-art photographs depicting black rites of passage. Eric works as a marketing representative for Georgia-Pacific. He resides in San Francisco, California.**

When I was a kid, we joined what is the *high-brow* Los Angeles Athletic Club. We were some of the only black people there, but it was a great club and we were going to enjoy it just like the rest of them. Later, I got into sailing, and I was the only black person there that did. For some reason—they say they could never find me—I was never around whenever they took the team photograph. I was on the racing team for five years, and I was never in one group photograph.

I never really made a lot of friends there. But then, I never really made friends in my black neighborhood either because I talked a certain way and I went to Notre Dame Academy, a private grade school. There were about four black kids in my class, and no black teachers. You know when you were in school and there was one kid who was picked on? I was that kid.

I learned very early on that I have to be my own person, and while I can be interested in what other people say, I've got to do what I've got to do. I was living in a black neighborhood, and the black kids there would beat me up because I would talk white. Then, I went to a white grade school where I was getting beaten up. Teachers saw me as the little, black, bad kid. When, in fact, I was not the one instigating anything. It was the kids who were putting cockroaches in my book bag, tacks on my seat, and dog crap in my desk. My color was the problem both ways.

Just getting in my car as a black man is an issue. But I'm going to go wherever I want. If I want to go to Beverly Hills, Brentwood, my own backyard, or my own front step, I'm going to do it without having a policeman, or somebody else, harass me. And, unfortunately, the opposite of that does happen.

Black people have bought into this concept that we cannot achieve, and if we make some achievement, then they are moderate achievements in light of Anglo achievements. We need to be aware of our history. There's more than Harriet Tubman and George Washington Carver. That's why education is the key. I feel as if I have to be my own lawyer, or my own doctor. When I go to a doctor, I have to ask a lot of questions like, "Why are you doing this?" and "Wouldn't it be better if this would happen?" I am certainly not a doctor, but I've learned through my experience as a black man to be suspicious and skeptical of everyone.

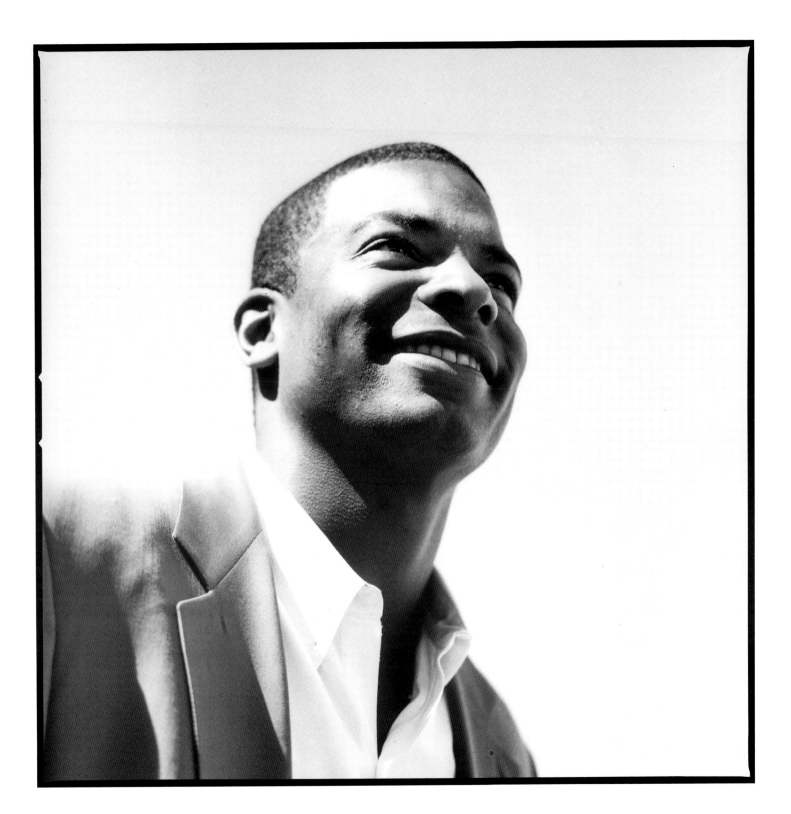

When I was around those kids at the yacht club, I was there to learn. I figured I didn't have black folks who loved me, and I didn't have white folks who loved me either, so I took it as an educational experience. My dad had me there to see beyond myself.

I think that African Americans, as a community, need to figure out what's going on in this country. We need to figure out how the American political system has decided that a few years of affirmative action equals our forty acres and a mule. We are a culmination of our experiences. To ignore who we are is to be sent off in a misguided direction. All of those historical scars are still with us.

I have a responsibility to acknowledge that my actions can be beneficial or detrimental to other people. If I don't do anything, it's always detrimental. If I try to do something, it's always beneficial. If we don't help ourselves, no one else will. Black people have to be self-sufficient. There are so many non-African American people who have helped African Americans. I don't want to denigrate that. I want to encourage that, just as I want to encourage African Americans to help people who are not African Americans. But we've got to take care of ourselves before anyone else can. If we can take care of ourselves, stand up for ourselves, and help other people understand our needs, then we can get other people to fight for us as well.

With that in mind, I collect photography concentrating on images of African American people. The central theme of the collection is "Rites of Passage." It's art, but it is history as depicted through art. I am fascinated by the concept of rites of passage and how black folks have evolved. I think of how my great-grandfather, who was a waiter and worked on a train, broke his back for his kids to get a little further. I love the concept of how black people have progressed and what it takes for them to get from one place to the next. Does it take a generation? Does it take a college education? Does it take shooting someone on the corner in order to be initiated into a *higher* society like the Crips?

When I was a kid going to the L.A. Athletic Club, I always thought how wild it was that I had this little plastic card with my name on it that said that I was allowed to go into this exclusive place. Then there was always that person asking for money outside of the building. God knows what life had put him through. He couldn't walk in that door. He didn't have what was required to pass through the doorway. What does it take to get to the next step? As we get to that next step, will we become superior in our awareness and sensitivity or will we become what we once despised?

Langston Holly

Born March 24, 1969. **Langston feels blessed for many things, but mostly for parents who instilled in him a deep Christian faith and a strong sense of black history, especially of the civil rights struggles of the sixties. A neurosurgery resident at the University of California at Los Angeles, Langston is a recipient of a National Medical Fellowship Award for Academic Medicine and UCLA's Ralph Ellison Award. He resides in Los Angeles, California.**

To be honest with you, I'm afraid of what tomorrow is going to look like. I went to a Martin Luther King celebration in San Francisco while I was in college at Berkeley. There were kids there who were acting up, and one guy was shot and killed. They had no idea what they were really there for. They were there to hang out. We've had folks in Arizona—the state recently passed the MLK holiday—telling us we couldn't even have a holiday. If we forget, then you know no one else is going to care.

It is a matter of giving those kids more information. We need to educate our children better. And we need to make sure that in our school system our children learn about famous black folks other than athletes and entertainers. Ask anybody who Michael Jordan is and they will tell you. Ask them about Eddie Murphy, Michael Jackson, or Prince and they will tell you. Ask them about Charles Drew? Langston Hughes? Some people who have really made contributions? They're not going to know. So, we have to make sure that we get this level of education in the schools' curriculum. When they learn about Thomas Edison, they must also learn about Percy Julian. That's what we need to happen, not just for our own kids, but for white kids and kids of other races as well. Then they will have more respect for our culture and more respect for us. Also, we need to do that in our homes—because what is not taught in the curriculum we must make sure our kids learn at some point. Although I wasn't learning all of the intricacies of the civil rights struggle in school, I was learning about them at home.

Civil rights was probably the biggest thing during the fifties and sixties, particularly for black folks, and we are completely neglecting it. I'm blessed to have two parents who were directly involved with it. I was watching the documentary *Eyes on the Prize*, and it was mentioned how the KKK bombed a dormitory at Mahary Medical College. I called my dad, knowing that was his alma mater, and told him what I had seen on the television. He said, "Son, that was one of the biggest noises I have ever heard in my life." When you're a little kid, your dad will tell you stories, and you might say, "Yeah, Dad, sure. Whatever." But when it hits home through a documentary, and your dad tells you that he was there? That blows your mind. Unfortunately, we're forgetting those stories.

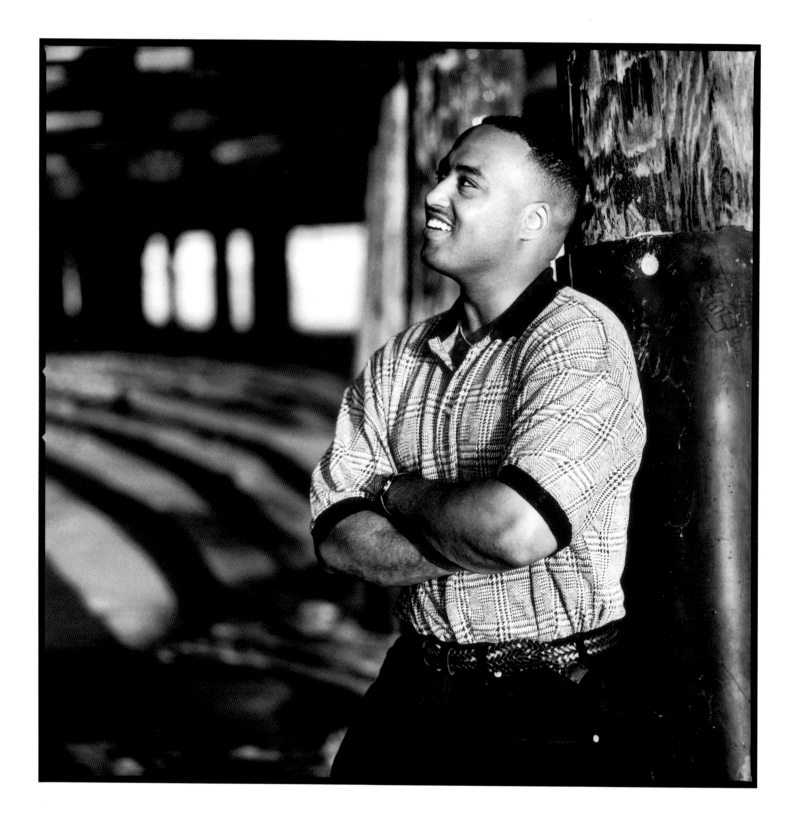

I believe that you have to perform at a higher level than your nonblack counterparts to get the same credit. But it's a catch-22 because if you are performing at that high level, then you intimidate your superiors, or your equals, since they don't expect you to be able to do that. They see you in a certain box, and if you exceed their expectations, then they are not comfortable with you. But if you don't perform at that level, then they're going to find a way to get you out of there.

That dynamic makes me stronger. Racism is usually the result of fear or ignorance. If you experience both of them, then you really have the formula, and you better watch out.

During my second year of medical school, I was at a hospital. So, we were four black male doctors walking down the hallway together, with one other physician. One guy—I am not sure whether he was a doctor, but he was also wearing a white coat—came up to us. In the middle of our conversation with our preceptor, he stopped us, looked at us and said, "Hey, what are you guys? Basketball players, football players? How would you like to play on our hospital basketball team? We could really use you guys." He had never met us before and had never seen us play ball before. For all he knew, we had never even played ball before. But he assumed that just because we were all black males, and we were together, then we must be athletes. That was one of our first days there. That's the type of thing that I run into. I've got plenty of stories, and they are all like, "Oh boy, here we go." But I would say that something like that story is more the exception than the rule.

I am a very strong Christian. It is the backbone of my life. For me everything comes off of my relationship with God. When things get tough, I think about a couple of Scriptures to keep me going through the day. Luke 12 of 48 says, "to whom much is given, much is required," and "to whom men commit that much to, that much more will be asked of him." What that means to me is when God has blessed me with many things, like a great education, and a great family, then he is going to ask a lot more of me than of the next person. But not only will God ask more of me, so will my community.

I put responsibility on my back and carry it like a backpack. That gives me strength. I thrive off of that. I am someone who makes things happen. I see something that I want, I figure out what I need to do to get it, then I go about getting it. I don't wait and let opportunities pass. I figure if God's blessed this to pass my way, I've got to make the most of it.

Just as I tried to find a way for the human immune system to defeat a tumor, I'm always thinking about how to improve things. I may be looked at as a perfectionist, but I'm always trying to improve myself and people around me.

Michael Gibson

Born May 4, 1975. **It is surprising that Michael is neither in jail nor dead right now. Instead he has accepted the challenge to rise above his circumstances and mentor those like himself, youth who grew up around drugs and found support in gangs. In 1992, Michael was sentenced to seven years at the California Youth Authority for attempted robbery, during which his cousin shot a police officer five times. While in the YA, Michael met Martin Jacks of the Oakland Mentoring Center, who began to inspire him to change. With the support of Martin Jacks, Joe Marshall, and Margaret Norris of the Omega Boys Club, an organization founded by Marshall and committed to helping youth break patterns of criminal behavior and violence, Michael did change. He was paroled after two years. Presently, Michael works as an office manager with Martin Jacks, his mentor, at the Mentoring Center. Cited by California governor Pete Wilson for his involvement in mentoring, Michael travels throughout the country speaking to youth about his experiences and the benefits of mentoring programs. However, as I found out over the course of talking with him, there are many obstacles to staying on track. He resides in Oakland, California.**

I was a sensitive child. My first memory is of my mother walking me to school and of me holding her hand. I remember seeing homeless people as we passed by a park. I let go of her hand and walked up to an old man eating something that he had taken out of a garbage can. I opened my lunch pail and gave him an apple. Then, I closed my lunch pail, went back to my mom, and went to school.

I grew up fast when my mother started using crack cocaine. There were times when my younger brother and I wouldn't eat. During the school year, there were times when we didn't have lunch. There were times when people would cook dope on our stove. When I would go to get a pot from the kitchen, I'd see the residue from cocaine, razor blades, and baking soda. I used to ask my mother, "Why are you doing this? Why are you using drugs?" She would say that her nerves were bad and she needed it to calm them. When I was eleven, I watched a man die of a cocaine overdose. I talked to people about my problems but they couldn't give good advice. Their advice was, "Here, have some of this." Then they gave me some beer or let me smoke some weed.

The older I got, the angrier I got. I didn't really give a fuck about nobody else or about the man pushing the shopping cart or the man eating out of the garbage can. I became mean-

spirited and hooked up with the wrong crowd. The only time I thought that I could cope, or deal with all the pain, was when I drank.

I started getting deeper into the drug life. I was still angry at my mother for allowing this to happen to me. I didn't have a life. I didn't have respect for life. I knew I would be dead before I was eighteen, so I didn't care. I felt like I was already dead. Actually, I was fascinated with the idea of getting killed.

I had an addiction to violence, or an addiction to the feeling of having power over other people. I felt like I was God.

For the first year and a half in the Youth Authority, I messed up gang-banging and fighting. I remember being locked up on my birthday and holidays and talking to my grandma. I would wonder whether there was something better, something different. Then I read a book, *Visions for Black Men*, which Martin Jacks gave to me.

I started reading and studying for a whole year. There were times when I could not be caught without a book. Then, I started writing. I gave what I wrote to Martin, and he would encourage me.

I started talking about peace. I got two gangs, the Crips and Bloods, together. We all got organized. We started cutting our hair and ironing our pants and T-shirts. We started going to the Muslim service and trying to be upright.

When I was paroled, it was a different story because both of my parents were in jail. I was broke. I had no clothes, no job, and no education. I did have forty ounces of beer and weed in my face, which I resisted for the first few days. I ended up taking a swig off of the bottle, a hit off of the joint, and the next thing you know I'm rolling up a whole stack of weed and drinking whole forties again. During my second week out of YA, I was riding around with a twelve-gauge, sawed-off shotgun in my hand.

One night, after coming close to getting shot and killed, I was sitting at home drinking a forty and watching my little brother play. That's when I decided to call Martin at the Mentoring Center.

[I scheduled a second interview with Michael, but he failed to show up. When we finally met again, he explained what happened.]

I was having a good day. Then I opened the door, and my sister was there with the police. She was crying and hysterical. All the policeman knew was that she had been sexually abused. Since she was pregnant, she had to go into surgery. The rape forced a miscarriage.

I felt like I needed to kill somebody. I made a phone call to let some folks know to come by the house. When I came back from the phone booth, this lady stopped me, and these were her exact words, "You kill his ass." I was hurting so much. The whole day I was feeling rage. I had to go back to the office and decided to talk to my mentor, Martin Jacks. He sort of comforted me. He didn't try to stop me; he just reminded me of who I was and how far I had come. Then I called Ms. Norris at the Omega Boys Club. Later, some folks came by with guns and gasoline cans.

My boys were talking about setting the building where the rape happened on fire and burning the whole block. I thought of what my mentor had told me and what Ms. Norris had said to me. I thought of all the people I have spoken to, and all the youth who have heard me speak. I thought of all the people who look up to me, or respect me, or know me for who I am today. All of that made me change my mind. I have to understand why the guy who did that to my sister is like that. I came to my senses and decided that I have to use the energy I was feeling in a positive way.

Someone has to be the adult. Someone has to be the smart one. Someone has to show the example and the leadership.

What kids need today is a lot of love. The reason why young people are the way they are is because of this: at some point we wanted love that we weren't able to get. Then when it's offered to us, we find it hard to accept because we feel like we already have it through the streets, drugs, or gangs. If a child lives with encouragement, then he will learn confidence. But if a child lives with criticism, then the child will live to condemn. These kids are used to being criticized as a person. It's alright to criticize the behavior, but not the person.

I'm able to articulate my experiences and present them in such a way that it makes people change. It makes people change their lives and open their eyes and broaden their minds. Joe Marshall of the Omega Boys Club says, "the more you know, the more you owe." It doesn't do me any good to have this knowledge and not share it with everybody I come across. People say you can't have your cake and eat it, too. Well, what's the use of having a cake if you can't eat it?

John Bryant

Born February 6, 1966. **In 1994, John was named by *Time* magazine as "One of America's 50 Most Promising Leaders of the Future." In 1995, he was named by *Black Enterprise* magazine as "One of 25 Future Leaders to Watch." In 1996, it was *Swing* magazine that called him, "One of the 30 Most Powerful Twentysomethings in America." These accolades might not be expected for someone who was raised in Compton and South Central Los Angeles. When he was young, John was a successful child actor who appeared on such television shows as *Diff'rent Strokes*. After a period of self-destructive behavior, he lost most of his money and lived out of his car while he worked to get on his feet again. Today, he is clearly on solid ground. In addition to positions in other businesses, he is the founder and chairman of Operation HOPE, a non-profit investment banking firm whose goal is to support businesses in the black community. He has been cited by presidents Ronald Reagan and George Bush for his business and community work. He and his wife, Arlene, reside in Los Angeles, California.**

First and foremost my mother was my role model. To a limited degree, my father, who owned his own business without much of a traditional education, was also an example. My mother once told me that the man can set my salary but I decide my income.

I was a child actor, and not a very good one, but I made a lot of money. I believed too much of my own press and made decisions more out of arrogance than common sense and I lost everything. I received a residual check of about $500 a month, and instead of renting an apartment, which was socially acceptable, I rented an office. At least it had the potential to make me some money. I made the conscious choice to live in my Jeep, and I decided that though I was broke, I was never going to be poor. To be broke, to be without money, is an economic situation, but to be poor is a disabling frame of mind that can be spiritual, mental, emotional, or intellectual. I decided to take responsibility for my life, responsibility for all those I had hurt, and to live for something larger than myself.

I couldn't fall from the floor, which is where I was, so the only place I had to go was up. For six months I lived in my Jeep behind a former restaurant near the airport. In the evening I pulled into the parking lot, covered the Jeep with my car cover, crawled into my sleeping bag, and read books under a nightlight. I tried not to call too much attention to myself. I got up every morning and went to the office and worked; I did that until I could afford to rent a room in a house. Then I shared an apartment, after that I shared a condo, then I rented a condo, and so on and so forth.

I was primarily raised in Compton, in Los Angeles, and later in South Central. In many ways what you see on television is a true depiction of Compton and South Central. Unfortunately, it is conveyed in ways designed to sell newspapers. Bad news sells, good news doesn't. The part of South Central that is depicted on newscasts is not an inaccurate message, but it is far from the total story. Eighty percent of the people who live in these communities are good people who go to work, or are looking for work, and want to live the American dream like everyone else. It is the 20 percent, who wouldn't save themselves if you put them in a wheel barrel and helped roll them to the finish line, who are spotlighted. To a certain degree the people who live, or have lived, in these communities, like myself, have a responsibility to repackage and resell the message.

I think that everybody has the potential to suceed. Everybody is special, but most folks don't leverage the potential to exploit their own individual talents. As a result, most people end up underwhelming. I didn't have a choice. When you are homeless, you have a great motivation to get off your ass. I don't do poverty very well. I never have and never will. Probably my greatest paranoia is to one day be broke and, God forbid, poor. I work very hard to avoid being either. Some might argue that I work too hard.

All of that work is connected in me, trying to be a good husband to this wonderful lady, Arlene Bryant, and trying to manage all the change, pressures, expectations, and pace of my life. When you don't do anything, nobody expects anything of you, but the more you do, the more people expect.

I think one of the problems in mainstream America is that assumptions are made on faulty premises. For example, there is a perception that poor people are poor because they are lazy. No. They are broke because they can't get a job. They are poor because they have a low self-esteem. Self-esteem in not a natural occurrence. It is nurtured. So if your mother was a drunk and your father was never home, then your chances of generating a healthy self-esteem are slim to none. You start from where you stand, and your role model then becomes the drug dealer and your example a pimp.

You have to believe that you can succeed in this country, particularly if you are of color, because you enter the race with a handicap. We have to always be aware that we are in America on a pass. Black folks are always on probation in America. The O. J. Simpson case is a great analogy. A writer in the *Los Angeles Times* said that when a Caucasian man is indicted for something just as heinous, the entire white race is not unilaterally judged or evaluated by

that person's experiences. But black men, and black folks in general, were definitely assessed in the O. J. Simpson case. Simpson bought his way off like countless Caucasian men have through history. Now, all of a sudden we have an intellectual riot in the call for a literal overhaul of the judicial system. Where was all this outrage before O. J. Simpson?

Operation HOPE was founded after the civil unrest of 1992. Although it really doesn't speak to its real mission, it is America's first nonprofit investment banking organization. It was founded to revitalize communities in hope, self-esteem, and opportunity. It is a continuation of Dr. Martin Luther King's dream. He had started the poor people's campaign to fight for economic parity. Essentially, we have taken up that mantel and said to black America that they must still be stakeholders in the dream.

Being an African American male gives me a tremendous sense of responsibility. Part of it is to reeducate America. The traditional educational deficit is in minority America, but the nontraditional deficit is in mainstream America. There is an arrogance in mainstream America that says, "I already know. Therefore you need to learn." That's a very dangerous philosophy to have in a millennium where very soon the minorities will become the majority and markets will change. If you don't change with them, you will end up with a larger and larger share of a smaller and smaller marketplace. I am suggesting to mainstream American business that you cannot afford the line item called discrimination. It is no longer in vogue because it is no longer economically viable.

I would like to tell African Americans that it's what you don't know that you don't know that kills you. You think you know. You fought for civil rights, so you think you should always fight for civil rights. Then one day you wake up and can't figure out why black folks are not doing any better, and it dawns on you that you are not in a socialist or communist country. You are in a capitalist country. We have to connect social justice with economic parity and connect all of those things with self-esteem, hope, and opportunity.

I would argue that the obsession with being liked is one of the worst diseases that black folks have. Business isn't personal. My pastor says that black folks take the rain personally. Our experience has been so painful that we tend to take everything that way to the point that we become overly sensitive. Sometimes things happen to you because it is a shitty day, or you are in the wrong place at the wrong time. The reality is that the victim generation is gone.

Anthony Mark Hankins

Born November 10, 1968. **Anthony has been making and design-
ing clothes his entire life. In 1994, after creating a successful fashion line for J. C. Penney as its
first in-house designer, he had a revelation on a commuter train and decided to start his own com-
pany, Anthony Mark Hankins, Inc. He is its vice president and chief designer, and he has 70
percent ownership. In its first year, the company generated $28 million of business. He resides in
Dallas, Texas.**

I always wanted to be a designer. When I was six, I sewed my first outfit for my mother;
even with the crooked seams, she wore it to an event.

I have always been drawn to the sewing machine. Throughout high school, I had a little
shop in the summer. I made outfits for the marching band, school plays, winter formals, and
the prom. When I was sixteen, I had the opportunity to do an internship at WillieWear. It was
a life-altering experience in that I saw in WillieWear what I dreamt for myself. I also learned
that no man is an island. If you are going to be successful, you have to have people around
you who care about you. Yves Saint Laurent gave me money to go to the École de la Chambre
Syndiale de la Couture in Paris. Again, it was a life-altering experience, since I would be in a
room full of people who were there because of their money or because of their name. I was
there just because I was talented.

When I came back to the states, I went to an interview at J.C. Penney for a quality con-
trol position. I didn't know anything about quality control, but let me tell you something, that
was the best thing to ever happen to me. I became analytical. I became a great writer. I became
a detailed designer.

I came up with my fashion line concept while I was in quality control. It is geared
toward women of olive complexion and brown skin. I thought of it four years ago, and
nobody was doing it. No one was thinking about the changing demographics of America.
I presented the line to the Penney Company, who said, "Well, we'll take it in 62 stores to
see what happens." But 62 stores out of 1,400 is not much. It sold, and since I'm pushy,
and I don't take no for an answer, we went to 170 stores and from there 324 stores. We
added large-sized, petites, and extra tall, and the line became a major label for them.
Eventually, what would have happened is that the line would not have been as important
to them as it is to me, and I'd become a backseat player. I'm not comfortable being some-
one's last-year's story.

At some point I was on a train to Rochester, New York, heading to a fashion trunk show. Someone in front of me was reading *Connie Chung: My Trial and My Tribulations*. And I said to myself, "What are her trial and tribulations?" But what I found was that she wasn't able to get herself together until she was able to get her own people in her corner. So I thought, "If Connie Chung can do it, why can't I?" That's when I decided to start my own company. Now the Butterick Company is going to put me on the front cover of their pattern books. I've got Target and Mervyn's selling my other label, called Authentics. I've got Avon, and now I've got QVC. Now how do you like me? To be a good designer you have to be smart. You have to be a good listener. You have to be able to touch people and feel what they are.

But I didn't know there was so much politics to be played in the fashion industry. I didn't realize how white people control this industry. Why was there only one Willie Smith here and one Patrick Kelley there? Other races need to be enriched by my culture just as I need to be enriched by theirs. Unfortunately, there are some African Americans in corporate positions who want to make the change, but even they need a catalyst. That's why when young people tell me they want to go into fashion, I tell them they better make sure they have recruited people on their side to support them through thick and thin.

When I was young, there were people there for me. My teachers, my guidance counselors, my mother's friends were all there for me. That's why I tell the people who are working for me that they will not offend me by keeping a portfolio. It's so important that people do the best they can and use opportunities to the best of their abilities to get where they want to go. If you have a job, it should be a means to get you to where you want to go next. Don't look at it as the end of the road.

When I was in high school, all the black kids thought I was so white. I knew I had a soul, and I knew who I was. I come from a long line of people who fought for everything they had. My grandfather was a sharecropper, and at one point my mother was a single parent raising seven kids. I am so aware of my culture—more aware than anybody knows. I love my people and every complexion they have. I think part of what drives my design is that I want people to feel what I feel when I see a black person.

Julian O'Conner

Born November 26, 1974. **When Julian was deciding where to go to college, he wanted to go somewhere challenging. He chose Dartmouth, an ivy-league college in New Hampshire, which for a street-smart teenager from a Bronx project was about as unfamiliar and unexpected as he could imagine. Now a senior, he is studying sociology with a concentration in education. His other concentration is Studio Arts. He resides in Hanover, New Hampshire.**

Until I was thirteen, I lived with my mother and older sister, Jacquese, in a Bronx project. I had never met my Pops before that time. My mother was addicted to crack by the time Jacquese became pregnant at fifteen. My mother was constantly telling her to have an abortion, but my sister didn't want to have one. To get away from my mother, she tied bed sheets together to sneak down the side of the building. We lived on the seventh floor. The sheet snapped, but the only thing that happened was that she had a compound fracture in her leg. However, the Bureau of Child Welfare started an investigation, and when they saw our living conditions, they told me that I would be living with my father from then on. When I did live with him, he didn't try to be authoritarian; instead he helped me make decisions. He taught me through his own experiences.

While I was living with my mother, I really wasn't going to school. I don't know how I graduated from elementary school. I think the school office knew I wasn't going to class but they just passed me along. It wasn't that I didn't know the material, I just didn't like going to school. When you are poor and you don't have clean clothes, you don't want to go and be teased about it.

What changed everything for me was the COOP test to get into one of the Catholic high schools. I was one of two students from my high school to get a scholarship. It was the first time I was recognized for being smart.

Part of the reason why I decided to come to Dartmouth was because it was so different than the Bronx. But what I find missing is the sense of mentorship for African American students. Although there are black faculty members on campus, the only contact you may have with them is if you take their class. There is no one to say, "Well, Julian, I notice you haven't been doing well in class. What's going on?" It is at a point where the only support that we get is from each other.

One of the things that white students will always note is that "all black students sit together at lunch." I point out that all the fraternity boys sit together at lunch as well. Those

students who complain have never made the effort to come to our table. It always seems to be necessary for black people to extend themselves. I guess they see us as having to do that if we want to get ahead in this society.

When I came here and measured what I had done against where I had come from, I realized how much I had accomplished. In the ghetto, you are exposed to more bad options than you are to good. A kid growing up in Beverly Hills couldn't really learn how to be a drug dealer, but in my neighborhood that was the trade you learned first. I knew people who were a lot smarter than me, but they decided to make their money on the street. Some of them had a family to support. Many of them think that if their parents couldn't support the family, then someone had to.

Truths, absolutes, rights and wrongs are all grounded in perspective. Most drug dealers would say that they are businessmen who have a product and are filling a demand. The issue of it being morally wrong is balanced by the thought that even though it may be killing the person taking it, it is saving their family.

When you come from New York, part of your street smarts is being able to meet a total stranger and get their name and phone number on the spot. If you couldn't make fun of your peers or if you couldn't yell at somebody, you were considered weak. These things build character because you learn humility. You learn how to be humble, but at the same time you learn how to be charismatic and how to make people laugh. In general, you want to avoid making someone angry because the most important part of growing up in the city is to avoid getting into fights.

You have to give the game face, and that is what I had when I came up here. I didn't know that I could take down that shield and just be myself. I came up here and I thought there was something wrong with everyone else. After a while I thought it was great because I couldn't get robbed.

One of my central philosophies is to learn from other people's experiences, instead of learning through trial and error. Part of that is to submit your ego and admit that someone else may be right and you could be wrong.

I received a Rockefeller Brothers Scholarship for Education and needed to do something in education administration. I knew I could go to New York and work in the inner city, but the only way I would truly learn was to pull myself out of my comfort zone. When I came to Dartmouth, I learned at shock value how to deal with white folks. That was when I was truly

learning. My next challenge was to go into a prison and teach inmates to read and write. I wanted to see whether inmates were really just people—because up until that point I had an image of the guy in prison just banging out weights all day, not speaking words and grunting all the time. Most of the guys in prison were not like that. They had families, and when you talked to them, you couldn't guess why they were in prison.

Because I was working in a predominantly white prison in Vermont, I was able to see into the lives of the people who live in rural America. Most of them didn't even know how to count their change. Teaching them brought a reality of American life that I thought didn't exist. Now I can say that there are places that have it just as hard as the inner city. There are hard times everywhere.

When I was a child my mother *was* able to give me something. She gave me the self-confidence to feel that whatever I was doing I could be the best at it. I remember drawing ugly pictures as a kid, but my mom would tell me how great they were. Then she would buy me a box of crayons. If drawing was what I wanted to do, she would encourage me and give me all the time in the world to sit down and color. As it turns out today, I am a pretty good artist. When you get that encouragement, you feel like a superhero, in that you can beat all the bad guys and still get the girl. I would say that I am the last black superhero because if it were the end of the game and there were a couple of seconds left, I would want to take the last shot.

Keith Knight

Born August 24, 1966. **Sometimes a single event can shape the course of your life. Keith discovered he could draw comics successfully in high school, and he has pursued that dream ever since. He now lives in San Francisco, California, and he draws a comic strip called *The K Chronicles*, which appears in several newspapers across the country as well as on the Internet. He has a book being published by Manake Press in the fall of 1996 and is one-half of the rap group The Marginal Prophets. He teaches and lectures on the subject of media literacy and at one point he was the director/editor/costar of a monthly cable TV show called *Bruno MacPush*.**

I have a twin sister who is the exact opposite of me. She's a girl and I'm a boy. She can sing and I can't sing at all. She has a nine-to-five job and I have trouble getting up before eleven.

To this day I still have a strip that I drew in the ninth or tenth grade. It was a parody of *Animal Farm*, and instead of animals taking over a farm, students took over a school and kicked out the teachers. I was the head, like Napoleon, and made the rules, which were, "Under eighteen? Good. Over eighteen? Bad." I passed it in instead of making a report, and my English teacher went nuts, saying that it should be printed somewhere. That's when I learned that drawing could get me through school.

My comic strip, *The K Chronicles*, was developed out of something that I started in eighth grade. It is semiautobiographical, and you should keep that in mind because if I really drew about my life, it would be the most boring stuff in the world. When I was younger, I remember my dad sitting down and drawing with me.

I didn't see my parents as human beings until I hit a certain age. I didn't realize how tough it was for them to be together, but now I know that they did it for us. I think it was kind of hard for my dad. His father took off when he was really young and shortly after that his mom died. So he was raised by my uncle, my aunt, or his grandmother. Looking back on it now, my dad should be praised for the job he did with us, since he had nothing to draw from.

Although he may disagree, moving to San Francisco was the best thing I have ever done. It was the first time that I was farther west than Philadelphia. Traveling is the biggest education you can get. When I was growing up, I didn't think I'd ever leave my hometown of Malden, Massachusetts. Then when I went to college, I said, "Oh my God, there are other cities and other places to go." Then when I went across country, I decided that I had to go and see the rest of the world.

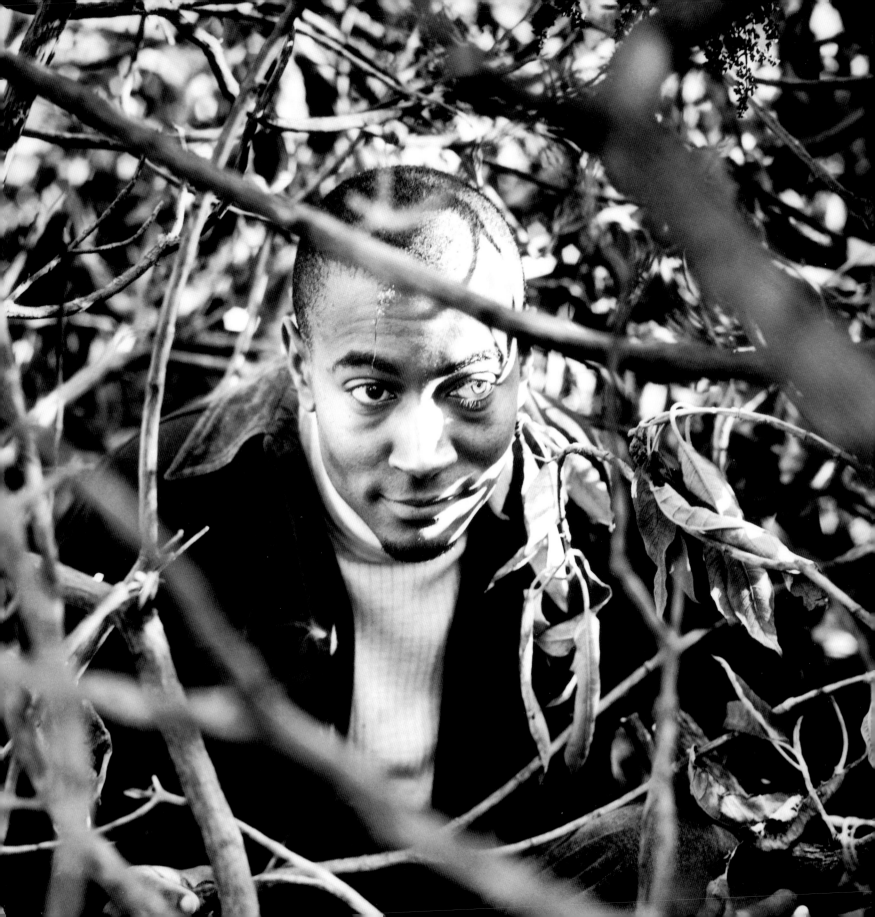

If I were dictator of the planet, I would kick out every kid when they turned eighteen, and instead of a military draft, I would send them to another country for six months. When you travel, you learn so much about yourself as well as other cultures.

Arriving here was a challenge because the question became, "Okay, you're here. Now what do you do?" The answer was do what you want to do. I did it and I am still doing it. The strip would never be what it is now if I hadn't come out here. I used to think that a comic strip had to be a little daily panel. I didn't even imagine a tiered strip until I came out here. I was able to see all of these underground comics I had never seen before.

When people read my strips, they may only get 70 percent of it, but that 70 percent is enough to make them laugh. Someone else may read it and get another part. There are certain parts that different people can relate to. On one level somebody may be able to understand it because they are an artist. Someone else may understand it because they are black or Latino. Or someone else will laugh because they have also had a snot in their nose when they went to the dentist. There's nothing worse than finding that out after the visit. I wouldn't care if the dentist was some old rotten guy. Anyway...

Anybody who has a strip that is pretty much about their life, and is talking about themselves all the time, has to be an egomaniac. I make fun of myself enough that people see it as self-effacing. So people think, "He's an egomaniac, but at least he has a sense of humor about it." People realize that I don't take myself too seriously. Sometimes I sit there and ideas just come, and I think, "Genius, man. Genius." Sometimes it is like getting blood from a stone.

In a very subtle way I make sure my strip represents black people in all aspects of life. Not only do I include black people but women and other people of color. One of the things I look for is how women draw women, how Asians draw Asians, etcetera. That's how I figure out how to bring certain characters across without being obnoxious. I am just doing what I do. It's not because I'm trying to be politically correct.

There is one artist I work with who told me how she wishes that she was black because of all the opportunities that black people have that white people don't. She mentioned all these grants for people of color and affirmative action. It's funny because it is a total misconception that black people have benefited most from affirmative action. White women have. She has.

I tried to get into a dialogue about it, but other people are really not convinced that racism exists because they don't witness it. Of course, I'm going to catch a cab if she is standing with me, but it's hard to convince her that I don't get picked up by cabs when I'm alone. I'm

trying to work my exchange with her into a comic, but I don't use the comic to vent my anger or to serve myself. I want to do it in a clever way that can hit home but will be humorous, too, even if it is in a sad, pathetic way.

I feel as if I am on a certain track. Every once in a while I hit a pebble and I fall off. But that awareness of falling allows me to get right back on it. I don't let it bring me down because the way to roll with the punches is just to deal with it. One of the challenges of life is deciding what to do when someone throws you a curve ball. I'm happy where I am now. But once I feel like I am content, it will be time to shake things up a bit.

Everyone is capable of doing certain things: you just have to be able to go after it. There are some people who say they wish they could have done what they love, like I did. I say, well, why don't you still do it because we only live once. It's so foolish not to do what you want to do and what you like; it's the road on the way to your goals that is the most interesting part.

Kevin Ladaris

Born September 22, 1974. **Kevin is a community activist who also has sickle-cell anemia, an inherited blood condition historically common among people of African descent. In spite of his sickness, he focuses his energy on organizing and educating young people. Kevin is the development director and community trainer for Youth Task Force, a collective of young organizers working for environmental and social justice throughout the South. In 1995, Kevin established a community activism scholarship in his name for students at his former high school in Camphill, Alabama. He is enrolled at Morehouse College in Atlanta, Georgia, where he lives.**

I am a skinny kid from Alabama who gets bored easily, so I keep myself busy as an activist. I was one of the founders of the Leadership Development Project, an idea that came from the anniversary celebration of the Selma to Montgomery civil rights march, where civil rights leaders came to our Alabama town to speak. Since they were all assembled, we thought they should say something to the young people. So we set up forums for the leaders to talk to the youth.

I received my first hands-on experience with direct action when it was discovered that students at Selma High were being tracked. Essentially, the black students were being tracked to lower levels. We picketed, boycotted, and staged a sit-in. Not surprisingly, we were arrested a few times. [Tracking is a controversial practice where school systems measure, or track, students as *slow* or *fast* learners and place them in different classes. A disproportionate number of students of color tend to be tracked into the slower classes.]

I went through the initial excitement of participating in an actual protest, of being involved in an activist movement and effecting change. Once that wore off, I recognized that more people needed to be involved. I began to think a little bit more strategically. For example, after three or six months people began to fall away. Or, it was 110 degrees, and only five people would be picketing in front of the mayor's house. It was the same process that people went through in the sixties.

That incident was good for me because I realized that there was only a small number of people who were actually brave enough to protest. One teacher lost her job because she spoke out against tracking. I realized that there were people who were amazingly dedicated, who did not have a lot to give but who did have too much to lose. Since it was such a small group of people, I couldn't slack off. Some people have to assume more leadership than they normally would. I fall into that category.

I want to work in partnership with student groups on campuses, primarily the historically black colleges. Many times we overlook the fact that part of our culture is rooted in activism and

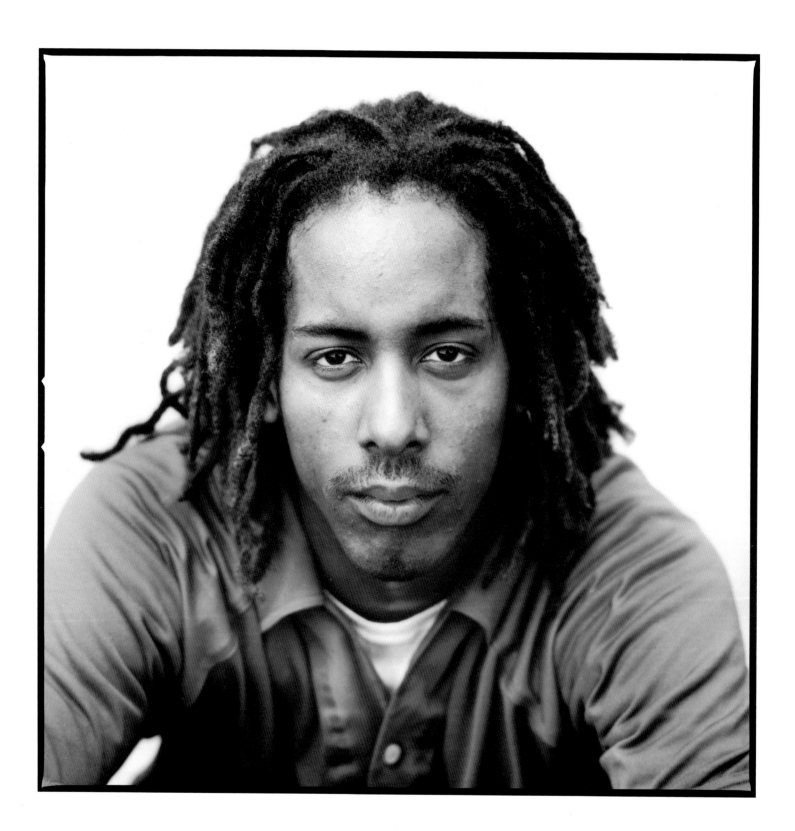

revolutionary thought. It is a part of who we are, and the larger cadre of people who under-stands that is evolving. In fact, we are doing hip-hop forums and using music as a tool for orga-nizing. I want young people to realize that organizing can be a career and a viable alternative.

I look at the statistics on black youth almost daily. Some of us have the idea that racism doesn't exist or that we have no control over it. But the more I talk to young people, the more I see a glimmer of hope. If you don't believe there is a chance in hell that people can overcome their oppressors, then there is no way in the world you can talk to young people. Unfortunately, the oppression takes many forms. I hear kids say, "Yeah, I had to slap her." Or, even more incredible are the girls who say, "He hit me because he thought that I was seeing someone else. He loves me." That's amazing to me. My first response is, "Are you crazy? Are you losing your mind?"

The first step in fighting that thought is making them realize that they have a personal connection to the effects of those thoughts. They can't just say that somebody hits their mom. It's deeper than that. They have to talk about how they feel when they see someone hit their mom. The first step is making people realize they can be personally affected.

My mom, who was divorced from my dad before I was born, could not get a job. When she got one, she could not afford daycare for her three children. But I was one of the lucky ones, in that my grandmother, and my godparents, took care of me. My grandmother had more concern for others than she did for herself. I have sickle-cell anemia, so I am often sick. She was there for me every time. The crisis usually lasts for five days and puts me out of com-mission for that time. When it is over, I have to get right back up and catch up on everything that I have missed. I have adjusted well.

I have had to adjust since there is so much apathy in our communities and in our fami-lies. Every time you turn around, someone is down. If it is someone who organizes, then they are depressed about the issues. If they are outside of organizing, then they are depressed about their family position. I refuse to live my life that way. A long time ago I was told that people with sickle-cell don't live longer than thirty-five or forty years old. I refuse to be negative at any point in my life because I may not live that long. I am happy, but it took me a long time to be happy. I plan on living and enjoying my life and the people in it.

When I saw that I was connected to everyone else in this world, and their problems were my problems, and their victories were my victories, I realized that I could stay grounded in my community.

Kevin Young

Born November 8, 1970. **Not many people decide to become poets these days, but Kevin has. In 1995, his first book of poetry, *Most Way Home*, was published by William Morrow & Company. He was awarded the Academy of American Poets Prize as a student at Harvard University and a Stegner Fellowship in poetry while at Stanford University. He is a member of the Dark Room Collective and has received his master of fine arts from Brown University. He is currently an assistant professor of English and African American studies at the University of Georgia in Athens, where he lives.**

Being a poet is one thing, being a black poet is another thing, and being a black person is yet another. None of them is more or less confining or inspiring than the other.

I started writing when I was twelve or thirteen, but writing became mine at such an early age that I don't think I was fully comfortable with it, I was just doing it. I always used to write little stories, and when I read a book I would want to write one. I would dream up these huge trilogies and sit down at the typewriter, but then when I was a page into it I would get bogged down in the specifics. I wanted every word to be perfect. I always had that poetic sensibility but poetry never really crossed my mind until I took a summer class with a guy named Tom Averill. It was a turning point for me because it made me realize that poetry was an option. After that I couldn't stop thinking about poetry. I would write all the time. I read whatever I could get my hands on.

I still barely say that I am a poet. People don't know what to do with you when you call yourself a poet. Derek Walcott once said, "You are only a poet after you finish a poem." With that said, I think that in whatever I do, I am first and foremost a poet. When I first started writing, I thought, "Why doesn't everyone want to write?" I was constantly trying to convert everyone into poets because everyone has that element of self-expression.

My expression took me to Harvard, where I was so relieved to be at a place in which I could talk about feelings and art just as a matter of fact and not as something strange. Getting in was my way of giving the finger to those people in Topeka who had tried to stop me along the way, in either minor or major ways. Some people don't want you to go beyond them. It may have been benign racism, but their thinking was, "You have a good shot at Harvard because you are black." In Topeka, my Harvard interviewer said to me, "Well, you don't seem black. You seem normal." It wasn't the 1940s. He was a lawyer, the university interviewer for

82 | 83

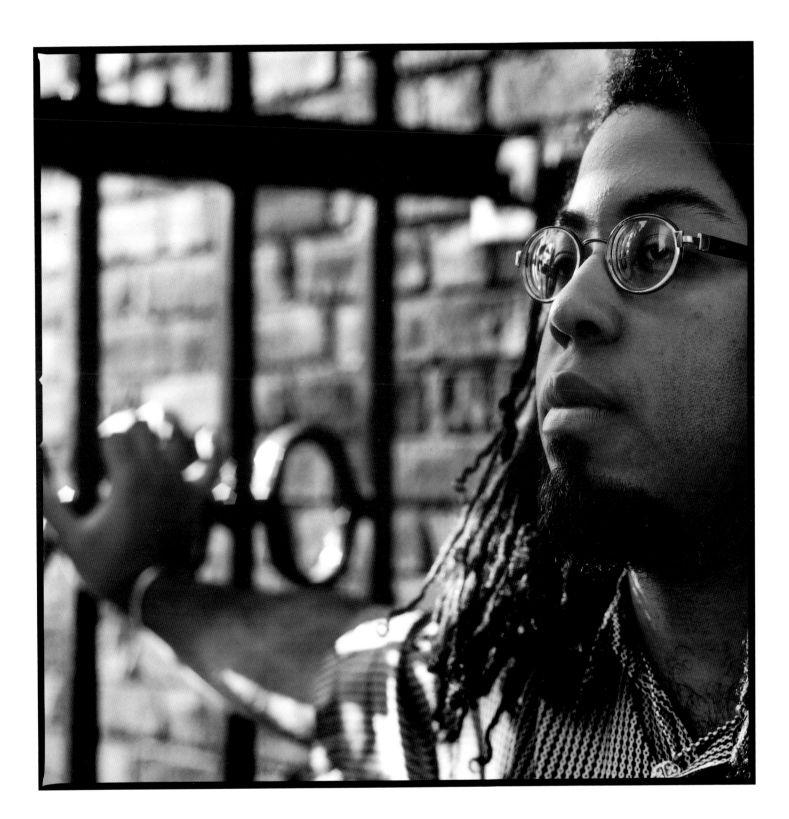

the area and a very nice man. He was even a liberal hippie. But that experience sums up why I left. When I got to Harvard, it was a breath of fresh air because I was with people who weren't afraid to talk about ideas.

It took me a long time to be comfortable writing the poems that I was writing. When I was in college I was writing beyond my confidence, in that my work was better than I knew it to be and that I felt comfortable with it being. You know how sometimes you can outgrow your coordination? It was like that; I had that kind of feeling. Eventually, I caught up with it and settled into my skin.

For the past two generations poetry has been taught horribly. People blame a lot of different things for it but in some way new criticism sort of alienates poetry. It makes people think poetry is this difficult, obscure thing that you are not supposed to get. For me, there is a mysterious pleasure to it. It is like hearing a song. You hear a song, and you trust whether or not you like it. Sometimes you have to hear it six times before you say that it is a good song, and sometimes the thing that drives you to like it is not what you like after a period of time.

When I teach high school students, I ask them what their favorite poem is and they can't really tell me. But when I ask them what their favorite song is, almost everyone has an answer because they may have a memory associated with it. I try to get people to work from that and see how poetry is like these everyday things. It is not about obscurity or looking up the allusions in a dictionary. There is a sense of that, but it is really about everyday language and life. Part of that life is the life of the mind, and part of it is the life of just sitting on the porch talking.

I think the things you need to do, as a young poet, are write and read. Yes, you need to go to readings and see what's out there, but you mostly have to get your writing done. People can get caught up in the *who I know* instead of the *what I'm writing*. They want the magic wand. People don't see the hard work, they see the end result. I'm not the kind of person you meet who, with sweat pouring down my face, tells you all the stuff I had to go through. I'm just going to do it.

Lucille Clifton wrote a great poem in which she says, "celebrate with me my life and how I had no role models being born in Babylon, both nonwhite and a woman." In the end she says, "Please celebrate with me that everyday something tried to kill me and failed." That

simplicity is wonderful. In part, it is why my role models are depicted in *Most Way Home*. They are the people who shelled the peas, picked the cotton, did all the work that made history, but at the same time made me. At the same time that is a metaphor for the creative process; it is also about preserving history.

It is almost morbid, but with my first book, I felt as if I had to get it said before something happened to me. In a way, it is an extension of the concept of preserving history. I was trying to get it out before either it went or I went. Some days it felt like I was going to go first. In fact, I remember hearing Derek Walcott say that it is when you are a young poet that you are connected to some sense of death. At that point it is a real, present thing and, I think, a part of what I was writing about or writing against.

Shannon Reeves

Born April 20, 1968. **Shannon has been a member of the NAACP since he was thirteen years old, and he hopes to be connected with it his entire life. It opened his eyes when all he could think about was becoming a professional baseball player. Today, Shannon is the NAACP's southwest regional director. At one point, he had been spoken of as a potential successor to Benjamin Chavis as executive director of the NAACP. He resides in Dallas, Texas.**

African Americans have to fight for world respect. You see, the world watched African American suffrage and formulated their perspective of African Americans from what they saw. That's why there is *Darky Toothpaste* in Japan. They don't respect us. But at the same time, African Americans are divided. There are something like three hundred national black organizations in the country. So I think the challenge is to find some cohesiveness in the struggle in order to attain this respect.

When the world sees African Americans as people who control about $437 billion in this country, and we determine that we are not buying Japanese cars until we own more of their American dealerships, and when African Americans in this nation exercise our power—and keep in mind that power is something that will never be given; it's either going to be taken or created—then worldwide respect will be granted for our community.

I thoroughly believe the NAACP is the best vehicle to soothe the problems in the African American community because it has eighty-six years of history. Regardless of its deficiencies, it has respect. But the problem is that the mindset of the NAACP is to survive rather than to change. And it's difficult to survive if you don't change.

Twenty-five or thirty years ago freedom, drinking fountains, and wanting to sit downstairs in the movie theater were on the agenda for black folk. Everyone was willing to put in the time. This is 1995, not 1965. We don't have *Freedom Summer* anymore. Now we have Hoop-It-Up. Now we have SuperFest. The emphasis now is on having fun. Therefore, what used to be almost mandatory volunteerism twenty-five or thirty years ago is zero volunteerism in 1995.

It's not about marching for the right to eat at the lunch counter. We've done that. IBM is not trying to make personal computers anymore. They are trying to enhance what they have made. The fight now is one where we have to organize the entity. The challenge is to be effective without having to go out and picket or demonstrate. Those methods take up an enormous amount of time and energy. When you picket, demonstrate, or boycott—and I believe they are

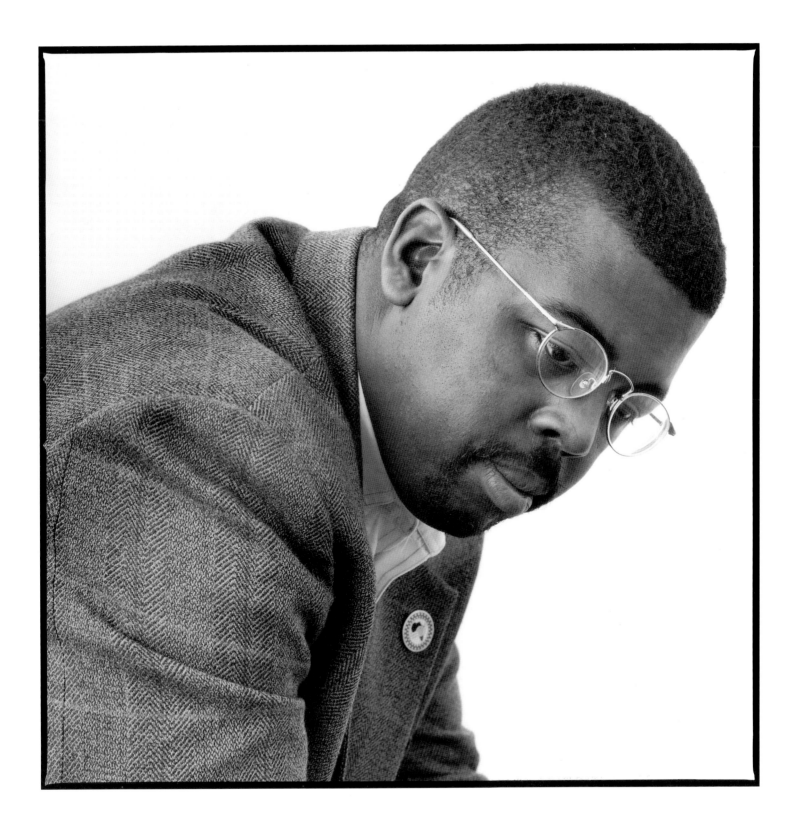

still some of the most effective tools we have—you've got to be able to measure your effectiveness. For example, if you demonstrate, you also need a press conference to announce it. A photo of the demonstration also needs to go out to every relevant paper in that area. Hell, if nobody knows what you're doing, you're not doing a damn thing. You're just mad on your own.

Another challenge for black leaders in America is to be patient. You can't always be headstrong and say, "Damn, we going to take the company down." Now if you find a kink in the struggle, then you must be patient enough to modify the struggle. It has to be something that you can measure. Like Thomas Todd, one of my mentors, used to say, "You can't teach what you don't know, and you can't lead when you won't go."

The question is always, "Well, what do you want?" Well, we want economic parity. We want equity. That's all we want. Nobody wants handouts. Nobody in my office is talking about a welfare program. But if we provide 15 percent of your total operating revenue, we want 15 percent of the jobs. We want 15 percent of the positions in management. We want 15 percent of the seats on the board. We want 15 percent of the advertising budget to go to black newspapers, publications, radio and television. We want 15 percent. If you're a stockholder and you own 15 percent of a given company, what would you want? You would want 15 percent of the profits. That's equity. You're only getting back what you put in.

I advise this to anybody who gets a letter from the NAACP, or any organization that has a legitimate concern. When you know you're wrong, and what's said in the communication is to some varying degree accurate, the first thing you have to do is meet with the people sending the letter. That's all you have to do. Nobody wants to organize a picket on everybody.

The NAACP prodded my mind to think from day to day about ways for positive change. I used to want to be little Joe Morgan. Until I came to the NAACP, I didn't want to do nothing else but play baseball. It really changed my whole attitude, and saved my feelings, because I probably wasn't good enough to play professional baseball. Hell, all I know, I could have been on strike last year.

I always want to be connected to the NAACP in some way, fashion, or form. Some of my passions are to really fight the corporate establishment for inclusion of African Americans. I'm a black, young Republican, and I tell the GOP the same thing, "I'm fighting for black folk. You all just be fair."

Darieck Scott

Born August 7, 1964. Darieck is a novelist who feels himself at odds with the expected or stereotypical image of what a black man in America is supposed to be: Darieck is middle-class, gay, and his partner is white. But he feels firmly rooted in the tradition of African American literature and in the belief that all black voices and experiences need to be heard and respected. Darieck is currently working on his Ph.D. at Stanford University, where he received his B.A., and he has an M.A. and a J.D. from Yale University. His first novel, *Traitor to the Race*, was published in May 1995. He resides with his partner, Steven, in San Francisco, California.

Writing fiction is using a universe of symbols, tropes, and figures of speech and recombining them to create your own personal mythology. Several people have said that writing fiction is like ordered dreaming, and for me it really is. It's like a dream, but you're just controlling it more—although, you still don't control it that much. You're giving it a direction, but ultimately, it's going to go where it's going to go.

People ask what I do and I say, "I'm a Ph.D. student." I do not say that I'm a writer. An academic is a profession. It's a slot that has been set, and a writer is not a set slot. It's not something you can claim that's readily understood, not something that's accepted without doubt or skepticism. I do need to write. I don't know whether I've isolated a reason why I do, but it's something that I've been doing since I was six years old. I might at any given time, just to relax or to make myself excited about something, write a manifesto or soap opera plot lines, which I love to do. Or I'll make up an alternate history of the world or create entirely different fantasy worlds. I just like making things up.

My holy trinity is Toni Morrison, Derek Walcott, and Virginia Woolf. One thing that I know I get from them, and there are many things, is the beauty of their language. All three of them are absolutely exquisite in their use of the English language. I mean their writing is so beautiful that it's painful. I have to stop reading; I can't take it. Whenever I read anything by one of those three, I do so very slowly because I really want to savor it. And it's not just beautiful language, it's beautiful language that has a depth and a substance that's inescapable. For instance, Morrison's and Walcott's work are both rooted in history and the political. Their writing has the effect of myth, somehow.

We need to pay attention to, and not just pay lip service to, the diversity in black communities. We are different from one another, sometimes in profound ways, ways that bring us into conflict. But even in conflict we can embrace the things that bind us together. Unity

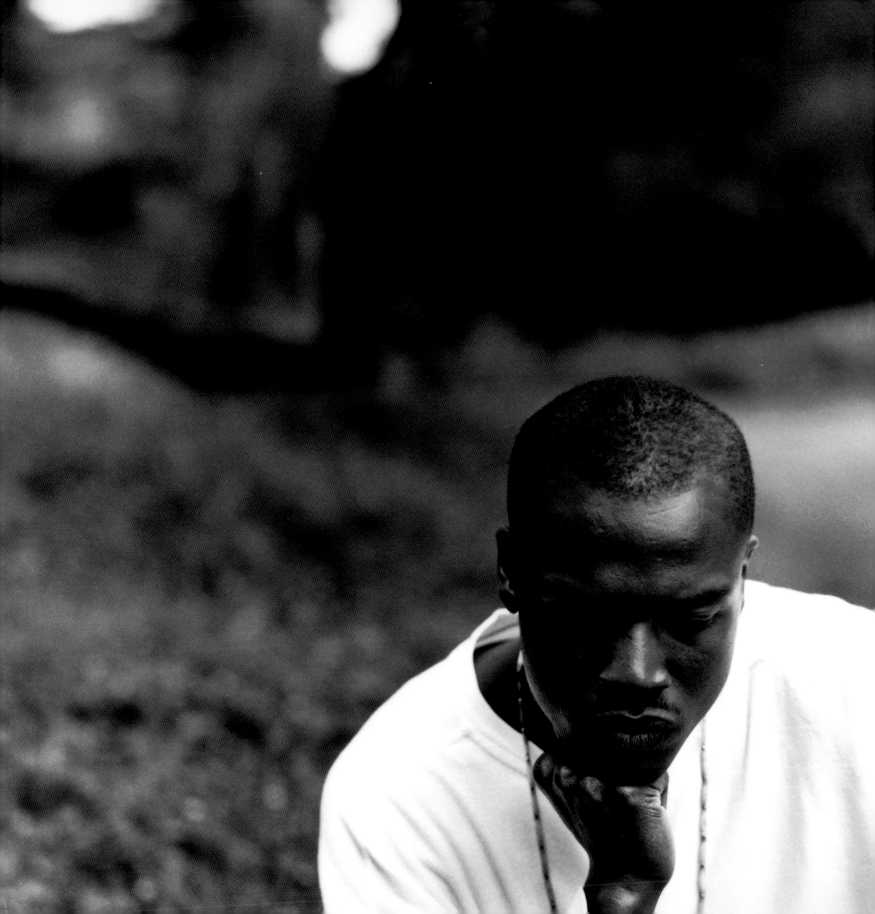

shouldn't mean conformity. We need to hear our own voices, so that we can respect what each other is saying, even though we're often saying very different things. And I want to point out, articulate, highlight if necessary, some of those differences. I want to talk about my experience and insist that it's authentically black in its particular way and that my kind of voice is an important voice to hear.

I want to speak in and from where I'm standing, and I want to stand there and feel not at all ashamed. There are a number of places where I could stand and be ashamed—I'm a black person who does not fit what I've often seen as the model. I'm from a middle-class background. I'm gay. I have a white education. I have a white lover. I'm not a musical artist. My artistry is in writing, and not even necessarily popular writing.

Although it's scary to say, I do feel that my responsibility is to my own vision because I believe that my vision is important enough, and is a contribution to, African American literature, as opposed to something that is not part of it. I'm not at all about, "Don't call me an African American writer. Call me a writer." I would be quite fine and happy to be known as an African American writer. But you understand that doesn't mean a limited thing. It means a whole range of things. It's not constrained. It's rich. I think whatever it is that I'm doing is a testament to that fact. I'm writing out of an African American experience, out of a gay experience, out of a gay African American experience. To make a division between them doesn't make sense to me. To say that my book, *Traitor to the Race*, is either a black book or a gay book is to say that you can only have a white gay book or an African American heterosexual book. Indeed, that's the way the industry is generally set up. But my work can't fit into that kind of division.

I think my life is about trying to work around constraints in terms of expression. I'm always writing African American literature, that's my milieu, that's what I know, that's what I have studied, and those are the tropes I'm using. It's African American literature and it's gay male literature, and in some fundamental way, one part cannot be cleaved from the other. The issue that led me to write my novel had to do with what it meant to be a traitor to the race. How do you deal with the concept, the idea, that you could be called that?

What I did in *Traitor to the Race* was take on what I thought would be one of the most traitorous-looking things: a gay, African American man with a sort of white icon lover. The protagonist, Kenneth Gabriel, is everybody, or anybody, really. Everybody could be him, in that anyone could feel cut off and ostracized from a group they desperately want to be a part

of. Kenneth has sort of taken on the fear of being a traitor; he has come to believe it, and his belief is a source of pain for him, almost more than how anyone actually treats him. Looking back on it, he was also a vessel for me to work through some of that pain for myself. What the book is about is this character's relationship to other black men. The interracial relationship is essentially a catalyst for that exploration.

I came out after years of very successful repression, where I didn't allow myself to know I was gay. Coming out was very stressful and absolutely liberating in ways that go far beyond sexuality. That was seven years ago. It was a big turning point for me in many ways—a lot of positive ways. I'm no longer wasting time. I'm learning to break down the constraints against my expression. I think my life was about working within those constraints before I came out. I would find out what the rules were and work within the rules so I would get it right, so I would be accepted.

Now I'm not just following rules. Of course, it's not as if I came to this immediately. It took a lot of time, and I'm still working with it. I feel like I need to do what I need to do. And I need to think that whatever I do is worthwhile. I'm still working on that part, and it's absolutely crucial. No one will believe in your work the way that you yourself believe in your work.

Khalek Kirkland

Born January 8, 1972. **Khalek's expectations are high, both for himself and for the seventh-grade students he teaches at Public Junior High School #113 in Brooklyn, New York. But Khalek has found that high expectations garner results. He is an instructor in the Summit Program, which is a program for exceptional minority students that accepts sixty out of three hundred applicants each year. He is also working toward an M.A. in education at New York University. He resides in Brooklyn, New York.**

My mother was really afraid that she would lose me culturally if I went to a school like Boston University or NYU, but going to Morehouse was the last thing I wanted to do. I remember telling myself that I was going to be valedictorian, and when I gave the speech, I'd tell my mother, "I hated the fact that you made me do this. I gave all my effort, and this was only for you." In retrospect, it has to be the best thing I have ever done. This is what I constantly tell my students: don't ignore the importance of going to a school where you're known by your name rather than your social security number, where people really care about you and your well-being.

Walking down the street, while growing up in Bedford Stuyvesant, I'd see younger brothers, and I might flex up or tense up. But after Morehouse, never did I do that again. There, I was never afraid—and I am still not—of someone of my own race robbing me. Growing up in Bedford Stuyvesant, that's what I was accustomed to. But there's nothing like having black students together in a positive way. Being able to look around and see young sisters and brothers on campus with the same mission made me start to see things from a different perspective. I remember, while I was at school, writing letters to my parents about the opening up of my mind.

My colleagues hear the name *Morehouse* and it says high self-esteem. They are expecting something great of me. I remember hearing Calvin Butts, the pastor of the Abyssinian Baptist Church, say to a crowd of students that he is never known as *Calvin Butts* when he has an engagement. He said people see him as *that Morehouse man*. I have always remembered that. When I open my mouth to say something, I have to remember that I'm really representing Morehouse, or that I am representing more than just myself. When I open my mouth, I am speaking for my parents, I'm speaking for the school, I'm speaking for the black race, I'm speaking for the black male. They are ways that people see me.

I take all that responsibility into the classroom everyday. I have to remember that I am the only black man they see in the classroom. I tell them, especially the younger brothers, the

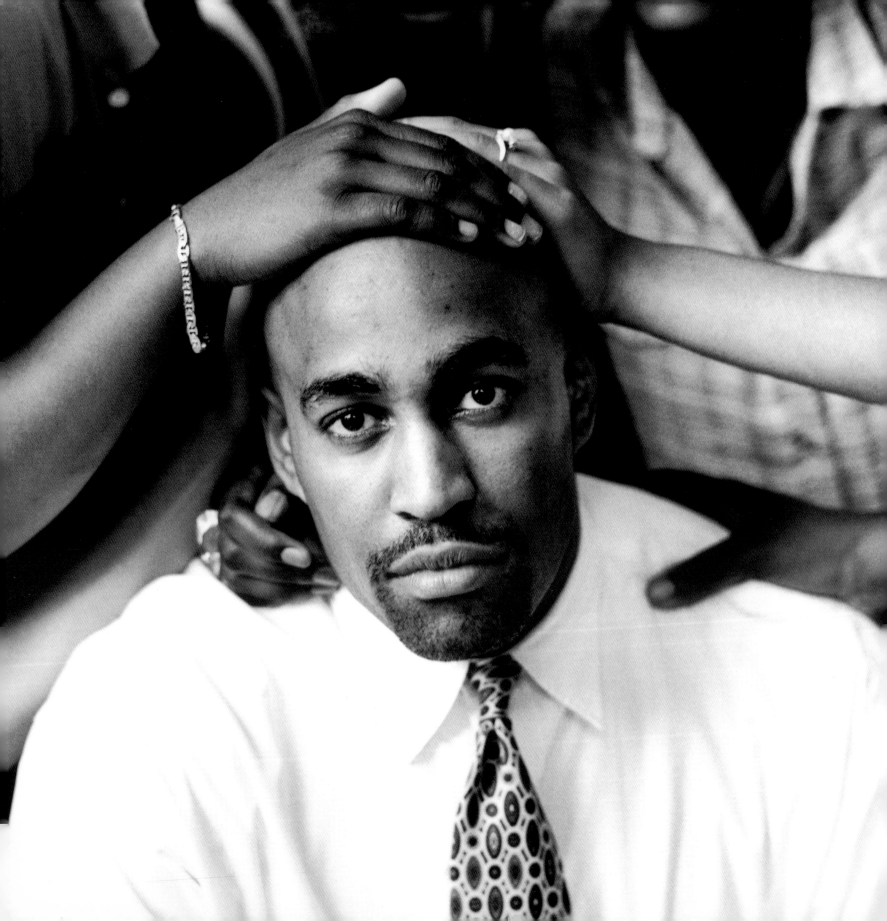

things that no one told me. I tell them that they need to go out in the world and meet other people and that every relationship they have is going to be a learning experience. I think the kids are really able to hear what I am saying because of my age. I don't think they know exactly how young I am, but they can see that I am young enough to understand them and to have gone through the same things they're going through.

Sometimes I won't teach a math lesson, but I do teach a lesson. Of course, some of them sigh and say, "Here he goes with another one of those speeches." I tell myself that as long as I'm getting through to one of them, it's worth the time. I've gotten letters back from former students who found out it was like I told them—they are the minority now. In this school most of them are of the same race. I try to tell them that it's not always going to be like this. I am dealing with students who are brilliant. They are students who are much smarter than me when I was their age. I tell them that, too.

Usually nothing positive is said in the teacher's lounge. We have a program in the school called ACE, which stands for Academy of Career Exploration. It serves as the zone program, which means if you don't get accepted into any other school district, ACE must accept you. I wasn't familiar with this teacher, and I asked him what subschool he taught in. He told me, "Oh, I'm in ACE hardware with all the nuts and bolts." This really told me what he expected. Of course, not knowing any better, I almost believed it, until I went there as a substitute teacher one day. I didn't do a math lesson. What I did was tricks with math. Once I got their attention, they just ran into that work. What that showed me was that they could rise to the occasion. But if you think they can only do one plus one, then that's all you will get from them. If you expect excellence, then that's what you're going to get.

I never looked at teaching as a short-term commitment. That's the belief I got from my father. He looked at his job from a relationship point of view. Telling me, "Don't ever get involved with someone or something that you can't see yourself involved with for the rest of your life. Because you never know what will happen."

Right now, even though it's a class break, I am thinking about what my kids are doing. Not that I have control over them, but I think no one else has the patience that I have with them. I pray for my children every morning. I pray to God to give me the guidance to teach them something new. I pray that they will be okay over the weekend. It's worrying about my kids that gets me out of the bed during rough mornings.

The board of education has a serious problem. There are tenured teachers who have been here for twenty-plus years. If I were to see myself in education for twenty-plus years, I would be trying to become principal. If teachers have limited goals, imagine what they are giving to the students. Whose teaching our kids? That question disturbed me, but at the same time it led me to teach. You have to want to be a teacher. You can't be forced into it. Too many young teachers use it as something to do right out of college. My goal is to be chancellor, not always a teacher.

I live my life believing "to whom much is given, much is required." Throughout my life I have been expected to accomplish certain things. My parents never had to chastise me. I was always counted on for eighty-fives and above. What I have done is try to take a little bit from every good teacher that I've had and make a better teacher.

kwami

Born November 7, 1970. **Sometimes our worst experiences lead us to our best deeds, and this is true for kwami. Though he never experienced much overt racism growing up, one violent episode led him to reassess his life. Now he is allowing the youth in his local community to have their voices heard. kwami is the founder, executive producer and host of PHATLIP! YouthTalk Radio, KABF 88.3 FM community radio. PHATLIP! is owned and operated by youths. kwami is also a cofounder of the Young People's Congress, a youth advocacy organization that is an extension of the radio show; it is geared toward involving young people in rebuilding their communities. He resides in Little Rock, Arkansas.**

My parents were divorced when I was in fifth grade. My dad was in the Air Force, and I guess I chose to go to the Air Force Academy because I had always wanted to follow in his footsteps, even though we were never really in contact. Since my mother was working three jobs, my two brothers and I raised ourselves.

Everybody talks about the problems of growing up in a single-parent household with no male influence. Well, I grew up in one of those households, and I didn't have that male influence, but I had it within me. So although I can't fault anybody else for not being self-motivated, I found that self-motivation within myself.

All the years growing up in Little Rock made me aware of racial differences and racial discrimination, but I had never really experienced it. I was such an outgoing person that I perceived myself to be a friend to everyone. All of that changed when I entered the Air Force Academy. That was the first time I experienced overt and covert racism. I was squadron commander at the prep school, and I chose my staff on their ability to get the job done and my ability to work with them. My staff ended up being all black males. People at the academy didn't like that too much.

We experienced many problems, but I would constantly tell them that everything was going to be alright. Then one day at four o'clock in the morning, I woke up to banging on my door. When I opened it, the only thing there was a burning black dog hanging from the doorway. There was also a Confederate flag pasted to the door. As you can imagine, all hell broke loose. Then one hour later when there was supposed to be the Stars and Stripes hanging from the flagpole in the courtyard, there was a Confederate flag in its place.

After that I stopped apologizing for racism and saying that everything would be alright. I went from being called an Uncle Tom to being called Cadet X. I left the academy, came

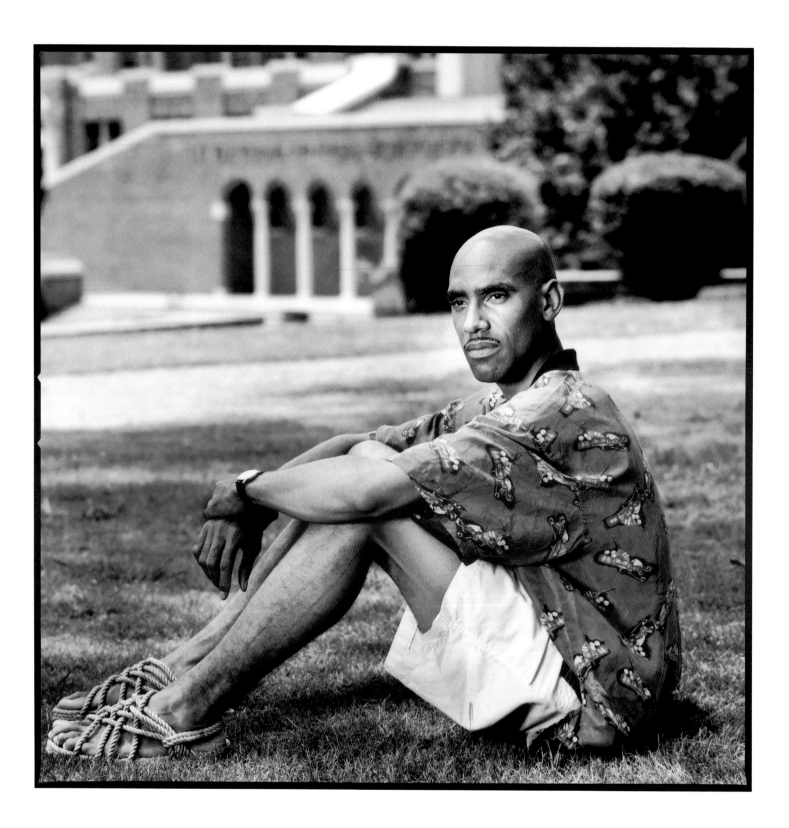

home, and legally changed my name. The experience exposed me to a worldview, and from it I picked up the phrase "think globally and act locally." Had I not left the academy, I would not be doing what I am doing now. I would be doing something for myself rather than for the community. I was very self-centered when I went to the Air Force Academy. Now I try to be selfless by seeing that life is all about what you can do for somebody else.

When I returned home after leaving the Air Force, I considered myself a failure because everyone was telling me that I should have stuck it out. As a result, I left Little Rock after being accepted at Morehouse College with a full scholarship. When I arrived there, they told me that I would have to apply for a loan rather than receive the scholarship that was initially promised to me. I felt that if I couldn't go on a scholarship, then I wouldn't go at all. I had a dilemma because I couldn't return home after I had just messed up at the Air Force Academy. I decided to stay in Atlanta and try to live the best way that I could. I ended up in the Salvation Army homeless shelter.

I wasn't too troubled by the experience, since I don't think you can be very successful if you don't have any adversity or any hurdles to go over. If everything is just handed to you, you don't learn anything along the way. I like to get out there and learn by doing. Frederick Douglass said it best when he said, "There is no progress without struggle."

I stayed at the shelter for about seven or eight months, but I spent my days reading at the library. One day as I was waiting for the library to open, a white woman sat down next to me and struck up a conversation. I was reluctant to talk to her because of everything that had happened at the academy. By the end of the conversation she had offered me a job at UPS. She also helped me get an apartment. Months later, a friend of mine opened up a juice bar and I helped him run it. One customer was a professor in a local college and one day she suggested that I be a guest teacher for her senior honors course called "Moral Problems in Contemporary Society." Her students really enjoyed having me and asked me to come back. That started the ball rolling in my becoming involved with youth and education.

I began to see how empowering education could be for young people. Eventually, I came back to Arkansas to supervise my uncle's recovery from a heart transplant, and I immediately started to substitute teach here in Little Rock.

At Henderson Junior High School, where I had a long-term substitute position, PHATLIP! was born. It happened during a seventh-grade social studies class. In the news there had been a lot of emphasis on youth violence in Little Rock. I asked the students why they

thought young people were acting so crazy. They responded by telling me that adults treat them as if they are nothing. They were made to feel as if they didn't have an active role in solving the problems. One solution the students gave me was for young people to take control of the media. So I had the idea of starting a radio show, and I challenged them to use it.

I don't like telling young people what they shouldn't do. I like telling people what they can do if they put their minds to it. As a substitute teacher, one of the problems I have with school is that there are so many rules stating what the students shouldn't do but no suggestions stating what they can do. A true leader is first and foremost a follower. A leader gets his power and authority by empowering his followers to do for themselves. You can't be a leader unless you listen to those you claim to be leading.

For example, the mission of the Young People's Congress is to mobilize the youths in Polaski County and empower them to make intelligent choices that will ultimately lead to their own transformation, the transformation of their families, and the transformation of their communities. Our goal is to rebuild our communities and rebuild our lives. We are the leaders that we have been looking for, and we are not looking for another hero. We want the youths to be independent, and after they realize they are independent, interdependence will follow. We believe that once we empower the youth to rebuild their communities, the schools will benefit, the churches will benefit, and the government will benefit. Everyone will benefit from us taking charge of ourselves and our communities.

There is so much power in the local community. If there was one thing that I could tell the young people of this country, it would be to live, love, and leave a legacy. I want people to know that I am real, my god is truth, and my religion is reality.

Ludovic Blain III

Born October 1, 1970. **Ludovic is a Buddhist whose religious convictions and experiences led him into political activism. Ludovic is the Environmental Justice Advocate at the New York Public Interest Research Group (NYPIRG). He spoke in front of 250,000 people at the Twenty-fifth Anniversary National Earth Day Commemoration in Washington, D.C., and he has lectured at over fifty colleges and universities around the country. He resides in Harlem, New York.**

My mom was raised in Harlem, and my dad is from Haiti. As a matter of fact, during my childhood I used to spend my summers in Haiti, where the class structure is much different. The middle class is able to sustain a higher level of living than they would if they were here. For example, we had maids there, but back in New York I was often eating government cheese. By going back and forth, I was living different lives in spite of the fact that I was the same person. It taught me that it is not the person who has anything, it is the circumstance. It gave me the confidence to believe that even when negative circumstances seemed permanent, they were, in fact, not integral to my life.

That realization was one of the reasons I was moved to do social action. It seemed unfair that I could live so differently just because of where my plane landed. I still stay on top of political developments in Haiti by providing technical assistance to Haitian environmental groups.

My basic fundamental organizing skills were developed during high school. However, they were not formed in the school but out of it. At that time, my mom was involved in a Buddhist group, and I couldn't deny that it was working for her, so I started to practice it as well. My main social interactions, development, and leadership skills were through the Buddhist group. In fact, I don't really remember studying in high school, even though I did fairly well. Almost every night and weekend day, I did some kind of Buddhist activity such as putting together meetings or phone banking with people who had joined but had begun to flake out. Speaking at meetings, doing cultural activities, and visiting people at home were all things that turned out to be the very basic organizing fundamentals.

The interaction of being a Buddhist in a Jesuit school led me to do things that were politically active in the school. I pushed for students not to be required to go to Mass when it wasn't for a specific school event. That was one of the first times that I stood up politically, and it was a result of a personally political experience.

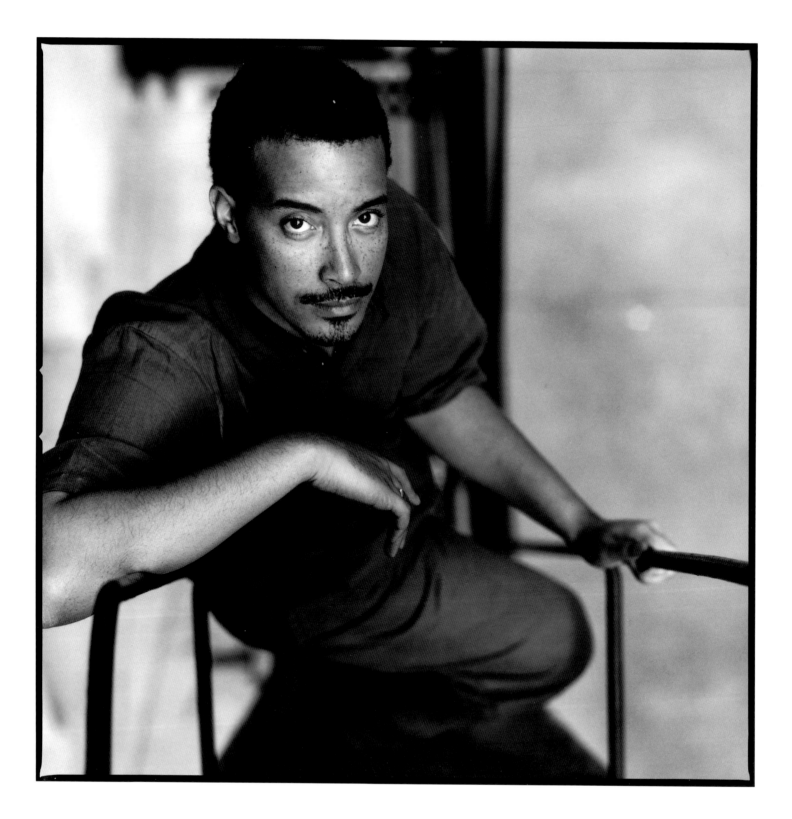

My religion is a fundamental part of me, and it has inspired my worldview. It is what everything else circles around. I learned that there is cause and effect and that the actions you take have reactions. I learned that people have a fundamental, absolute responsibility for their own lives. Buddhism and organizing principles are very similar. Unlike other religions where you have liberation theology—that is, you have the religion and then you add stuff into it— Buddhism incorporates the liberation part into the mainstream of the religion. The cause-and-effect teaching showed me that we can actually change our environment. You take actions, and then there are impacts to your actions. If you want to create a certain environment, you have to take the actions to move toward it. That understanding really shaped my worldview.

In Buddhism, there is definitely an impact for, let's say, running a pipe underground and polluting the water. That is a cause you are making. It is not just that there may be oil in the water, but there will be an impact in your life for what you've caused. With some aspects of pollution, racism, and other stuff, people think they can get away with them until they die. If people think they can get away with things in this lifetime, that will enable them to rationalize their actions. I construct the world as a Buddhist, and I walk through it and attempt to implement my decisions as an African American.

However, I separate being black from being African American. Being black is certainly to suffer worldwide racism and racism here in the United States. I am light-skinned, so I benefit from being light-skinned as opposed to dark-skinned. I have seen that in the different ways people treat me when I am with folks who are either light-skinned or white as opposed to the way they treat me when I am with folks who are dark-skinned.

Some of the differences are little things, like getting followed through stores, or where we get seated in restaurants. Those are class-based issues. You experience the class issues differently because people have a different perception of class, in that it is not just based on race but on skin color within the race.

Now being African American, I recognize that I certainly benefit from being an American— because although black people get bombed, for example, the MOVE folks, we are in a country that bombs other people. We certainly benefit from being in the United States. Although we certainly don't benefit anywhere near as much as white folks do here in the United States.

I don't know how optimistic I am, primarily because I am not sure that the specific psychoses of racism and sexism, but especially racism, are being in any way purged from the

folks who have it. We are doing a good job at impacting people, and we are doing a good job at mitigating the impact, but I don't know if we are treating the illness.

That is why we need "white studies" majors—not just European-American studies, but white studies, where a part of that is European American. We need some analysis of white leaders. We need to hold up white people who are doing good things, and we need to have some white nationalists who are progressive—people who are proud of being white, and not just of their ethnicity, but of being white. Because if the only people who are proud of being white are the Klu Klux Klan, then how else can the majority of us feel as brothers and sisters with the Klu Klux Klan?

The black community, on the other hand, needs to know that we cannot settle for leaders, like Farrakhan, who are less progressive than the Pope. In reference to both, I am using the word progressive very loosely. In addition to that our leaders need to be many and not just one.

Martin Jones

Born January 9, 1964. **Marty has accomplished what is still a rare thing today for a man of any age: he is a successful black man in Hollywood. Marty is the executive vice president of United Image Entertainment, an affiliated company of Black Entertainment Television. He owns his own production company, i.o.u 1 productions, which has created music videos for artists like Ice-Cube, Run-DMC, N.W.A., and Eddie Murphy. He resides with his wife, Teresa, and their daughter, Haley, in Carson, California.**

During my junior year at Denison University, I made a movie called *Castle 13*. It was about the White Castle hamburger restaurants from midnight to four in the morning when all the freaks come out. I held a benefit for myself, and let people know that I was going to use the proceeds to go to California. When people heard about the cause, they bought two tickets, five tickets, and ten tickets just to help me get there. I came to Hollywood, where I didn't know anybody, with everything I owned in my Toyota Tercel. Although I am not from a rich family, my parents supported me and told me to do whatever it took to fulfill my dream.

No one in my family told me that the dream was impossible. Unfortunately, I did have teachers tell me that it was impossible. They told me that there were no black people in the movie business, and that since I was a good speaker, I should be a lawyer.

I am a man of God, a husband, a father, and a filmmaker. It has been a little difficult lately, since I have had to wear my husband/father hat more frequently. There are guys out there who didn't have any men in their lives, so I make it a point to be in their lives even if it is just a phone call every two weeks, or a movie every couple of months.

I know what I want and I have been very patient about getting it. People see me as a guy who has been on a course and never gotten off of it. They see a guy who has achieved everything he has wanted to achieve in life except for one thing, weight loss. Luckily, I have a beautiful wife who didn't marry me for my abs—because if that would have been what she was looking for, then I would be talking to you from a bachelor pad in Hollywood.

It may be connected to my being molested by a cousin when I was nine years old. I don't know. On the scale of how bad it could have been, it was pretty minimal. But it still haunts me. I have begun to realize that men have a lot of the same emotional reactions to that kind of trauma as women do. One of the similarities is to become bigger and less appealing. In a sense, it is protection against being used as a target for someone else. I never really thought about that until I saw a show on BET, Black Entertainment Television, with men sitting in a circle discussing their experiences of being molested as children. At least now I know that I am not alone in this.

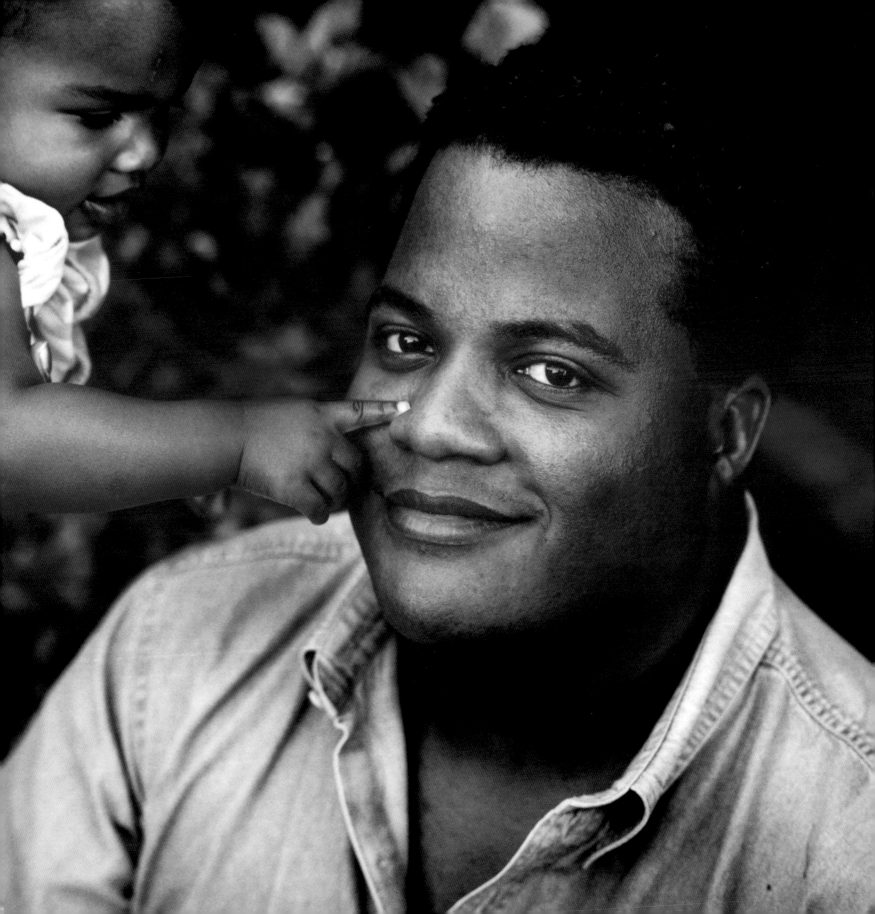

However, I keep my self-esteem because I know that I am a child of the Creator of this universe. I have a direct link to him through his son Jesus Christ and the Holy Spirit that resides in me and who makes me indestructible. Death can't take it away from me. Poverty or wealth can neither increase nor decrease it. Nothing can take away the incredible relationship I have with God. That relationship, in human terms, is like being the number-one son of Bill Gates, Bill Clinton, President Mandela, and the DuPont Family all put together in one entity.

In addition, I come from this incredible culture of people who invented mathematics. I come from people who built complex structures, from people who have made music into an incredible medium, and from people who have sweat and fought in a land they didn't even own to help build it into the powerful nation that it is. I come from the people who have endured racism and the Klu Klux Klan. I come from people who have worked in the fields of the South, taken the northbound train, endured, and then went on to serve this country in the military. My people are pioneers and slaves and kings and queens.

I would never say that I am a self-made man, and I hope to God that I never say that. I am the product of all of these people and their blood, sweat, and tears. That notion of pulling yourself up by your bootstraps is, I think, a very selfish, atheistic worldview. No matter how destitute or isolated you are, you are always, either directly or indirectly, the by-product of other people. I am a composite of people from the past, from my ancestry, and more specifically from my immediate family—my grandparents, my parents, my brothers, and my sister.

It becomes a constant battle to maintain that vision when I have to deal with certain experiences. For example, recently I had just finished having drinks with one of the wealthiest black men in America, when, dressed well, I began walking over to my new car. This was in Beverly Hills, and this woman and her daughter were walking down the street toward me, and as she got closer, she grabbed her daughter's hand and clutched her purse.

I am one of the most nonthreatening black guys you will ever see. But now I know that we are all scary and threatening no matter how we look. It doesn't matter that I speak the King's English superbly. It doesn't matter that I have medium complexion or that I have *good hair*. It doesn't matter that I wear sophisticated glasses or a nice watch or have a house or a car. Not one of those things matter because at that moment, I was just a nigger walking down the street. I don't ever forget it, but I don't carry it as a chip on my shoulder. I am very proud of who I am, but I refuse to be an icon for certain people even though they have made me one.

Matthew Hampton

Born November 21, 1975. **Matthew is doing something that everyone talks about but few seem to carry out—he is providing African American teenagers with jobs they care about. His dream is to inspire each of them to become young entrepreneurs like himself. At the age of fifteen he founded his own company, Team Connection, Inc., which provides services to individuals and local businesses in a variety of areas. Today he employs from thirty to fifty teenagers who do everything from building flower beds for the parks department, to handing out flyers, to building residential housing complexes. He resides in Little Rock, Arkansas.**

I am doing what I am supposed to be doing. Right now I am trying to shift the company from just getting contracts and employing ten kids to do it to getting a contract and enabling young people to set up the businesses around that contract. I want to see more young people do what I was doing when I was fourteen and fifteen. At that age, I was cutting grass and tutoring kids. I had Team Connection in all kinds of services, like typing papers and anything else that would make money.

Being able to accomplish so much at an early age has inspired other people's dreams. Just four years ago I was doing anything that I could to live. Now I am negotiating joint ventures with one of the biggest companies in this city. Last weekend, we moved a hundred thousand dollars in contracts. In four years I have come a long way, and it is directly because I was able to learn that strong work ethic when I was younger. I have come a long way.

I want to look back in ten years and see that a lot of the young guys who are with me now are still doing business with me. My dream is to have the resources to convert my ideas into feeding one thousand families. I want to be able to see my company put one thousand diapers on kids' butts. In ten years I think that will be a much better feeling than knowing that I have, let's say, thirty million dollars in assets.

One thing that keeps me going and really inspires me is the story of one kid I put to work. He was the epitome of the word *gang-banger.* He was the hardest kid out there, he had sex with all the girls, and anything negative you could think of he pretty much did. He wanted to go on a job and I was really excited for him because he used to talk about how he could make a thousand dollars a day selling dope. He got out there and was working hard. He told me that it just felt good to be out there because he didn't have to look over his shoulder.

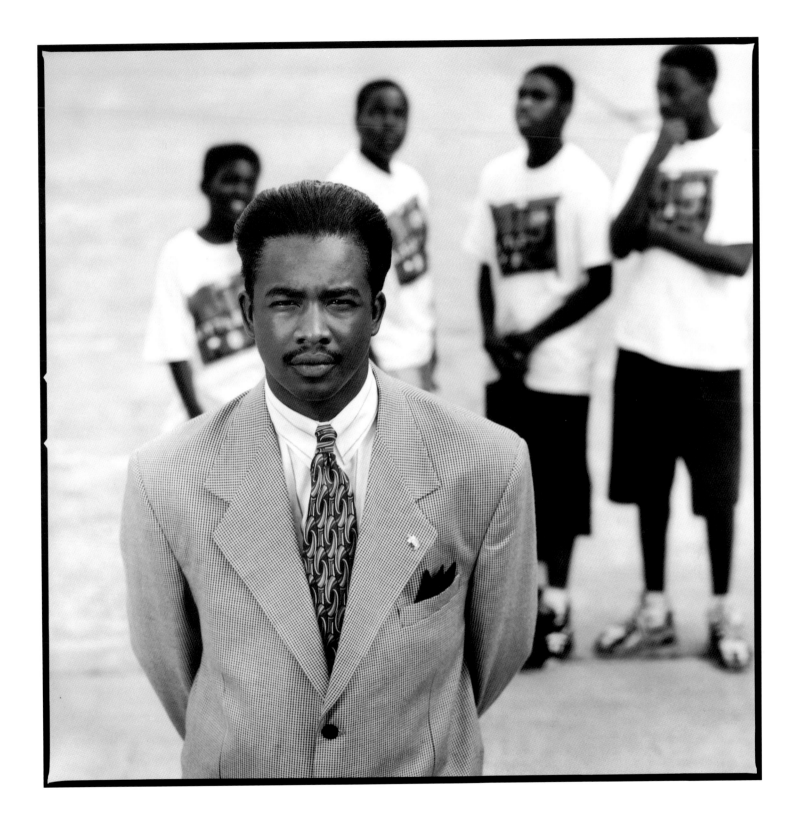

I kept him going on contract and he got to the point where he started thinking about how I was running the business. He started talking about college and starting a business of his own. A year later he decided to get away from the gang and he moved out to the country. He was there for six months and had no trouble. He came home one day just to see everybody, and on that same day he was caught in a drive-by shooting and killed. That was the hardest thing in the world for me to accept. He was only fifteen. But when I think about the impact that I had on him, I realize that I have to continue doing what I am doing.

If those in business take what we, as young entrepreneurs, are saying and doing seriously, it could have a real impact on employment and on other young entrepreneurs. The key to this whole thing is that most people don't take us seriously—because if they were, there would be a whole lot of other opportunities.

I have no hang-ups about anything African American. I have no hang-ups with anyone explaining experiences. Being African American has shaped the way I think and the things I notice. I see everything from an African American, male perspective.

In Little Rock we tend to hide race so much. To say the words *black* and *white* scares people. Possibly because of its history, it is still a race-sensitive community. I don't think we have ever really acknowledged it. We get together to have race-relations meetings and talk about whether there are any problems, but our communities try to hide and deny it. I don't go into business negotiations trying to hide my Afrocentricity. I simply speak from the perspective of a black person.

There are not many older African American businessmen here who I could look to as my business mentor or partner. Some of them have known me and what I am trying to do for four or five years, but they didn't have the respect in their companies to take me where I needed to go and to whom I needed to talk to—while white businessmen who are vice presidents of banks tell me that I should meet the president of the bank. Unfortunately, you don't have a lot of progressive blacks because the South is the South. It is not progressive.

My inspiration to start the business came from an article about young entrepreneurs that I read in *YSB, Young Sisters & Brothers*, magazine. I must have read it about fifty times. At the time I had a job at Target, and I told myself that if they could do it, then I could, too. I quit the job and spent the summer living in the small business development center. I met with black business people, and once again, many of them didn't take me seriously. I was hyped up

and excited to meet them, but then when I came in I would get dissed. Now, I just see those meetings as stepping stones to keep me going.

It is a constant struggle and a constant challenge. But it is something that is a good challenge and a good struggle for us to go through because it continues to make us stronger as a people. It is like a constant weight-training program.

The greatest part of running Team Connection is putting dollars in young people's hands. I feel great when we get through with a contract or when the kids get paid. It makes it all worthwhile to see them get their money and hear them talk about what they are going to do with it. That is the coolest thing to me. The hunt of going after the contract is fun, and when you see a client satisfied, that is also fun. But seeing kids with dollars in their hands, to me, is the coolest thing in the world, and seeing how that impacts them and how it makes them think, that's the greatest part of Team Connection.

I believe in the concept of minimizing and maximizing. We need to minimize everything that we don't have and maximize those things that we do have. If you try to start a company and you don't have a thousand dollars in capital but you have the time to plan it out and get other people to do it, you can minimize what you don't have and maximize those things that you do have. When we started Team Connection, we didn't have the money to go out and get equipment, but we did have the ability to write proposals to other people who would give it to us. If you are always looking at those things that you don't have, you will never really cultivate those things that you have maximum potential in.

Maurice Ashley

Born March 6, 1966. **Maurice is passionate about his work, whether it is teaching children or competing at his chosen sport. What makes Maurice different is that his sport is chess, and what makes him unique is that he is the world's first African American International Chess Master, which he achieved in 1993. Maurice became a National Master of Chess in 1986, and today he is an announcer for chess competitions on ESPN and EuroSport. He is a chess coach for two high school teams, an online tutor to children around the country, and the designer of a chess CD-ROM by Simon and Schuster. He resides with his wife, Michele, and their daughter, Nia, in Brooklyn, New York.**

I think chess found me. I happened to see a friend playing a game in class when he wasn't supposed to. We played a couple of times and he beat me badly both times. For no reason at all, except for maybe the fact that he beat me, I started taking chess books out of the library, and I became completely hooked.

Playing chess in the African American community was truly beneficial for me. Chess is seen as a prestige sport in the African American community. Kids who play chess are elements of pride in the community because they show that we are more diverse than what society tends to push as our images. I find that the community is very receptive to the intellectual pursuit. I often find that they really respect the game.

The parents of the kids I teach are the best. Most find it to be one of the most significant events in their child's life. It is something they know will help their children intellectually. They intuit that their kids will focus better, concentrate better, and become better at solving problems.

But you also find that the parents are extremely proud that their child is playing chess. I had a parent who thanked me for teaching her seven- or eight-year-old child to play. She told me that she actually plays the game with his uncles, but she never thought to teach the game to him. Now she sees him as this little intellectual. Most of my kids are average students, but she can brag about him and, of course, that makes him feel better and brings him into the family circle, since he can participate with his mother and uncles, who themselves have been playing for years.

Coaching has become my life. It has become something that I love to do and something that I couldn't see myself without. It is kind of cheating because although I understand the idea that it is something that I ought to be doing for the community, I already love doing it for myself. As soon as I saw these little black faces and the excitement they had, teaching became

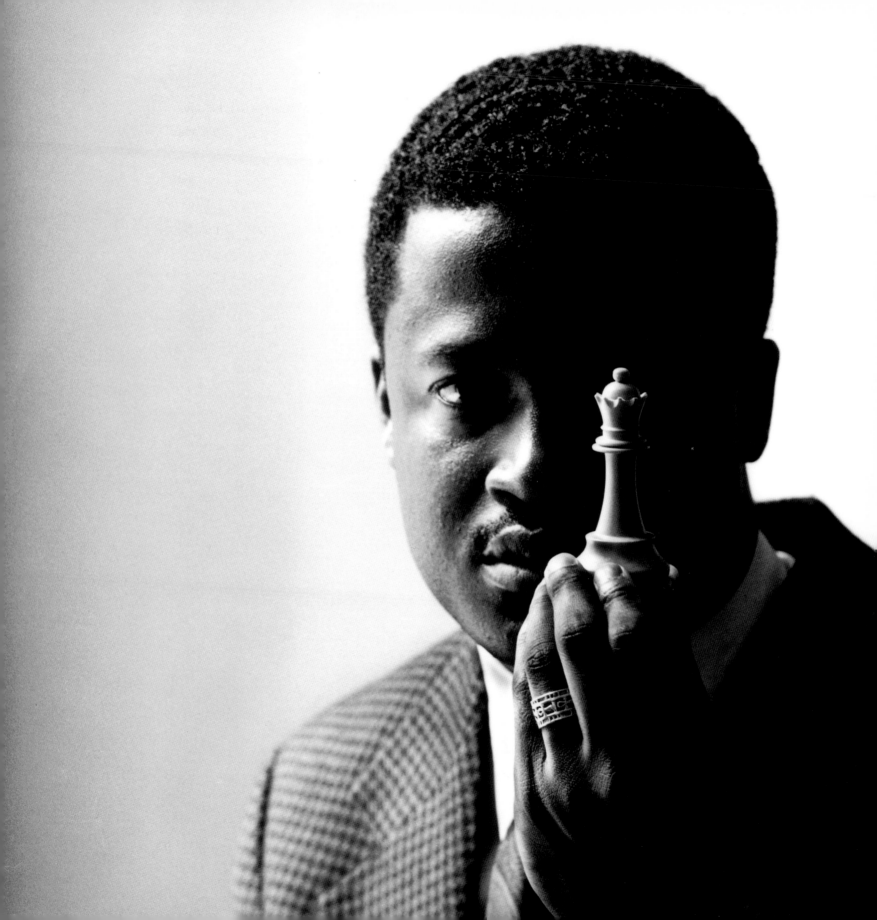

a part of me. I want to show that as an African American man you can pursue the intellectual side. It can be the primary component of our being, and you can still be strong. Unfortunately, part of our community defines strength as the ability to kill somebody, which is essentially the weakest thing of all.

I am a competitor. I love all sports. I love the setup of lose-win. I love the devices used to win. I also love the character needed to lose well. That has always been fascinating to me. Although it is a bit morbid—and the fact that people die bothers me—I find myself attracted to war because I like the concept of fighting methods. I think about war in terms that are purely strategic.

I can see the similarities between chess and war, but I also see the similarities with chess and everything. I think my great skill in teaching is that I make chess exciting by using many real-life sports analogies. I happen to have a million of them. I can talk about chess and herb tea and be able to find a correlation.

You really have a funny army in chess because the pieces of the army are so diverse. Somehow you have to bring this diversity together to make them work and accomplish concrete aims. You need to harmonize your pieces to accomplish one goal. That is true with anything and everything. In music you want to bring notes together and make them into a majestic piece. So harmony in music and harmony in chess are defined naturally by this harmonic connection.

For the Dark Knights of Mount Hall, the team I coach in Harlem, chess has become a sociopolitical statement. We have won two national championships, and I love to talk about our accomplishments in those terms because we have a big Hispanic student body, a smaller Asian student body, and a smaller African American body. We have this tremendous diversity on the team, but we all believe in one another. For us diversity is a strong thing, and we understand the concept of different elements coming together to work toward a single goal and being very successful at it.

There are some things that happen that bother the kids, however. Sometimes when we walk through an airport with a bunch of trophies, people come up to us and say, "Wow, what are those trophies for? Basketball?" They look at them and say, "No, chess." In fact, once we were called a rap group.

As a chess player, I am a first. I am the first and only African American International Master. So that is my special accomplishment, or my distinction really, since I don't consider it

a superior accomplishment. I am not proud of being the first African American International Master in the chess world. I am proud of being an *African American first* because I think that it is important that we break into all these fields and show how diverse and talented we are as a people. I am proud of being an International Master. But I am not proud of them going together because when it comes down to it, so what? I am not the best chess player overall, so I am not happy with the label. I am happy to break into a field like this one and pave the way. I am using such a powerful image in chess to show to fellow African Americans that we can do anything and succeed financially.

I feel proud to be in this field, but I feel proud as a member of all the African Americans who are succeeding in nontraditional fields. I feel proud to be a part of that group because we are paving the way for expansion into many different areas.

I was able to settle down and focus because of my wife. She set me at peace and stabilized a lot of the conflicting forces in me. She made all things clear because she was a solid component. She gave me a stable relationship that I never had growing up. My daughter, Nia, amplified that tenfold because she made it a real family, so to speak. These things are what organized my life.

If history gets it right, the first thing that they will remember about me is that I loved kids and I was passionate. It will be known that my first passion was opening children's minds. I have this feeling that history will not get it right, and instead, what will be said first is what I plan to be my next accomplishment, that is, to become the first African American Grand Master.

Michael Dorsey

Born May 28, 1971. **Michael is a dedicated environmental activist whose travels have convinced him that there is no worldwide solution to our problems, whether that's environmental pollution, economic inequality, or racism. He believes the solutions must be locally specific. In 1992, Michael was chosen by the White House as the youngest member of the State Department's delegation to the Earth Summit in Rio de Janeiro, Brazil. His activities there were captured in the television documentary *Green for Life*. He is a former lecturer at the University of Michigan College of Literature Science and the Arts, and he is pursuing his Ph.D. in anthropology at Yale University. He resides in New Haven, Connecticut.**

One thing I often reminisce on is the extent of racism at my high school in Southfield, Michigan, a suburb of Detroit. I was not as conscious of it then as I am in retrospect, but I can vividly remember people making comments to me that I was "not like the rest of those people." I not only remember the comments but I also remember my bewilderment. The first time I heard that comment, I thought something was screwed up with it. I wasn't sure what it was, but it threw me for a loop.

In an interesting way a similar thing happened here at Yale. A professor was writing some recommendations for me, and I went to visit with him to see whether he had finished. We were talking, and he said, "What you have done is really impressive stuff. You probably won't even need any affirmative action to get into any of these schools." That is not an example of redneck racism but of high-class racism.

Now when I reflect on my life as a young black man in high school, I recognize that my racial identity wasn't something I actively engaged in. I was conscious that I was black and other folks were not, but it was not something that set me off from the rest of the group. Life as a middle-school student in the suburbs was, more often than not, deracialized. The racial component was taken out.

On the other hand, in the college cafeteria, I on some level felt compelled to choose between sitting with a predominantly white group or with black students. White students would rarely comment on where I sat. However, it turns out that they would comment among themselves. Their take was that all minorities sat by themselves. Never did a white student come up and ask why black students sat together. I think white people don't see themselves as white but as normal. So if you are normal, you don't have to ask those kinds of questions. To me, of course, the question is, why do all the white students sit by themselves?

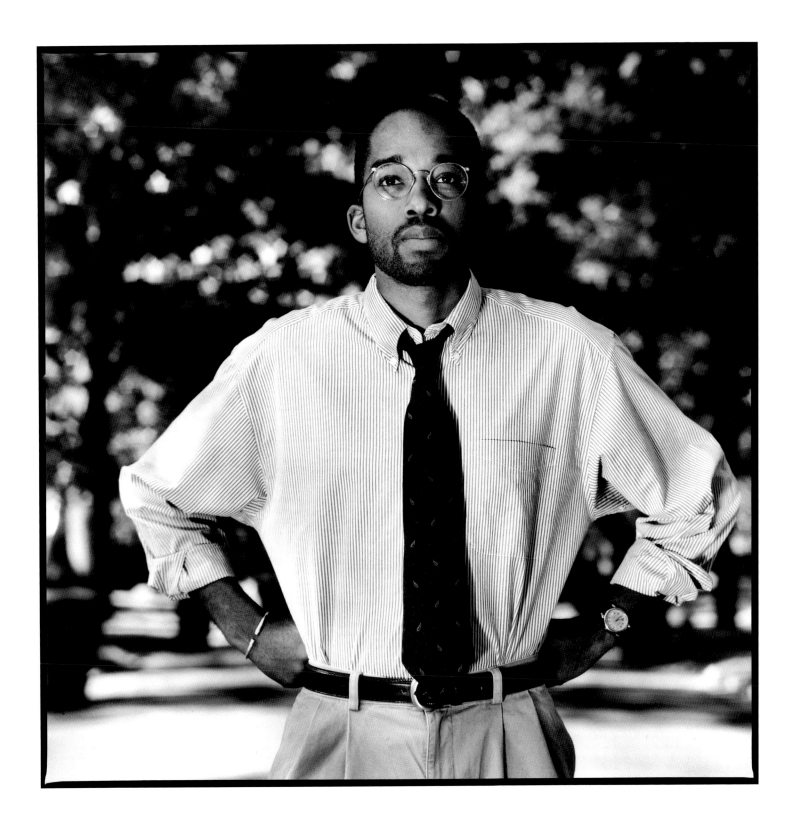

As I travel to new places, I am constantly altering my ideas. There is no way to understand a place until you have actually seen it. Nothing can replace the personal, visual experience. You can read a thousand books, see a thousand videos, or hear a thousand people talk about a place, but until you see it, you can't forge your ideas about certain things.

Interestingly enough, people think there is a universal theory about people in the world. But seeing different places, and being in so many different places, has impressed upon me the uniqueness of local life and how locally specific things and problems are. What that means for me is that there is no kind of universal solution that can be cross-applied over the world to solve problems. At a fundamental level almost everything that we do in environmental matters has to be locally driven and set up in a local context. Things may be grand and amazing but they are profoundly unique.

What keeps me going, albeit kind of cynically, is the concern that the issues that I am dealing with will not be resolved in my lifetime because they are so gargantuan and because the level of subterfuge and murkiness around environmental problems is so great. It is my strong belief that a major catastrophe will have to take place for significant change to transpire. As a result of that overall outlook, I feel compelled to—what I have been calling it lately— spread the gospel of environmental justice. I feel compelled because apathy is silly.

I want to make the "leaders" accountable. For me, that is an integral part of working on environmental issues. The goal is to attain justice in a broad sense, especially racial and class justice. It is becoming fairly apparent, and some people still don't want to believe, that there is environmental racism. Environmental policies have been and continue to be discriminatory, and in several ways there is racism within the environmental movement.

First and foremost, people of color and low-income people of color are more frequently exposed to toxic and hazardous wastes. Dump sites, hazardous waste sites, and landfills are placed in their communities at higher degrees and more frequently than in other communities. Then those other communities tend to get more of the good things, like parks and grocery stores.

It is like a double burden because, one, there is the obvious fact that low-income people are already struggling. And two, being dumped on is adding pain to misery. The effect is beating down further those who are already down. I am convinced that people don't realize that the legacy of slavery or the impact of racism has not been erased. You're talking one generation. A generation ago people were in an environment where they were being raised in the context of "White Only."

In spite of this, being African American never plays a role in my self-confidence. What it does play a role in is my conception and reconception of my effectiveness. For example, when I am lecturing, the fact of my identity is something that I am constantly thinking about, and because of that I must think about how I am going to best lay certain information on them. Not that I want them to forget that I am a black man, but I bring them whatever it is that I want to bring them in the context of my racial identity.

The drawback is that I have to constantly think about it in that context. It is not something that is subconscious. It is something that I am constantly engaged with, and I am going to be engaging with it until I die. Since I am a believer in the existence of racism, I know that I have to engage my identity in the presentation of ideas because I know that it is being engaged when people say, "He is so articulate."

I am a nice guy who is dedicated to making some amount of social change on the planet and committed to making people think about basic things in radical ways. Being a black man in the United States not only means that I should encourage and push people to think about basic things in radical ways but it also means that I have to do that because racism has forced me to.

Nathan Redfern

Born March 2, 1967. **Nathan is a former member of a well-known Los Angeles street gang, but he was able to turn his life around with help from Fred Newkirk, who took Nathan in at the Orange House—a safe haven in Long Beach, California, for troubled teenagers and those who seek refuge after spending time in prison. After the 1992 Los Angeles riots, Nathan was asked to go to Korea to help improve relations between the Los Angeles African American and Korean communities. Since then, he has been named a liaison/public relations representative for the two communities by Donald Gregg, the former United States Ambassador to South Korea, and the New York Korean Society. He resides in Long Beach, California.**

My mom was a strong lady. I was the youngest of thirteen kids, and my mother did it all herself. My dad used to beat her. I can remember one time in Queens, New York, he came zippin' down the stairs, and when I finally got upstairs, I saw my mom laying in a pool of blood. He had stabbed her twelve times. Later on she took him back, but he went on womanizing. One day his mistress became obsessive and shot and killed him. Two months later, my brother Mark, my mother, and I left for California.

Once there, my mother would be gone for most of the day, and my brother would leave in the morning and come back a few hours later with a thousand dollars. He would tell me to give some to Momma and to keep some to buy basketball shoes. He knew that I liked to play basketball. One night I heard gun shots from inside the house, and outside my window I saw my brother streaking up the alley. My mom came into my room with a gun in her hand and told me that she didn't want anyone who robs or steals in her house. She said, "If you ever give him any more food through that back window, I have something for you. I brought you into this world, and I can take you out." I will never forget that.

I started sneaking out of the house to follow my brother after my mother had gone to sleep. One day he made a mistake. He showed me what he used to do to get his money. He was thirteen or fourteen-years-old and would go to suburban areas to rob people. Eventually he got caught and sent to jail. He was gone for about six years.

During that time I established myself in his gang by becoming a shooter. My thinking was that of survival of the fittest. It was, and probably still is, like a chess game. If they take your pawn, you are going to want to regain the advantage by taking one of their pieces. If you are caught short of pieces, you can be easily overpowered. It's that simple. Unfortunately,

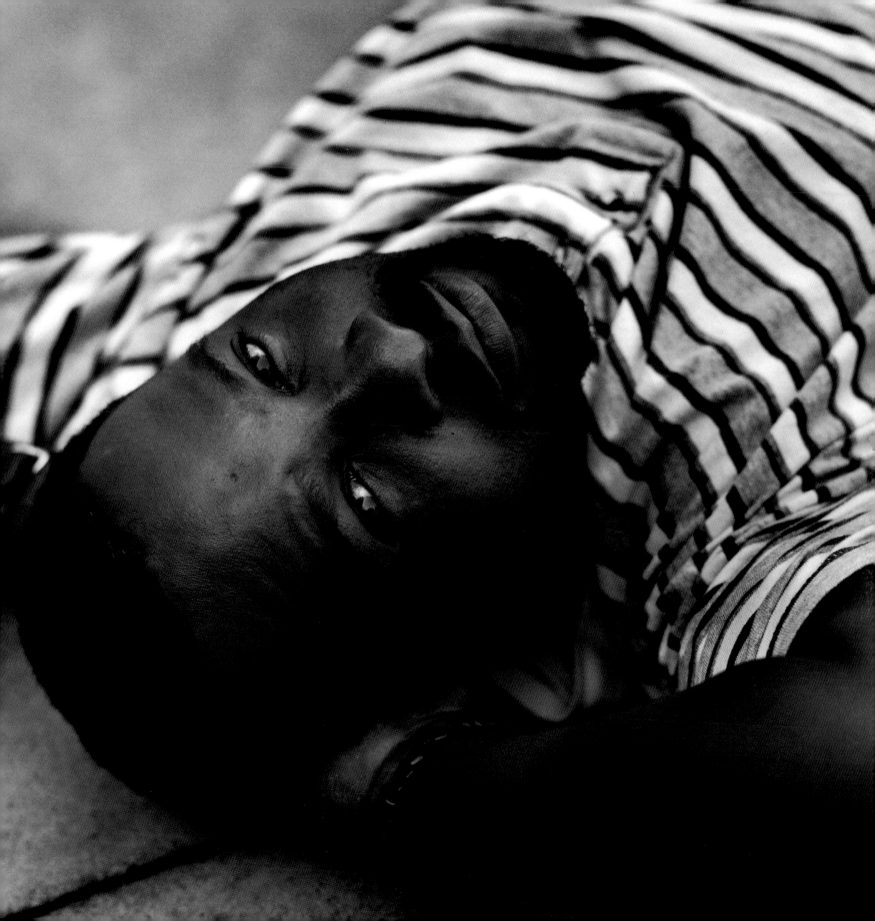

it took a long time for me to understand that I was involved in genocide. I finally realized that when I was seventeen and sitting in prison for attempted murder.

My soul was hardened. Life was catching up to me. You have to remember that at this time I was only twenty-five-years-old. I had been in prison, and I had committed murder. I was actually tired but I just didn't know it. I was tired of my way of life. But I went to jail again for selling drugs in the Orange House, a place run by Fred Newkirk, and the place I was able to stay in when I first got out of prison.

After I was released the second time, the first person I wanted to see was Fred. When he came by I just began to cry, and he gave me a hug and told me that he loved me and that he wanted to be my brother. Before that, the last hug I had received was maybe nine years before, from my junior high school basketball coach after we won the city championship. You may never send money to the inner city, but if you come down and work with the kids here, hug them and tell them that you love them and you sincerely mean it—that means more than one million dollars to a young person. That's why I started to channel my energies into something positive.

As time passed Fred offered me and my brother Thomas a chance to go with him to Washington, D.C., for the National Prayer Breakfast. He told us that the president, senators, and some other people were going to be there. We went and it was a moving experience. For my whole life I had thought that the white man was the devil and was the one that was keeping us down. When you are part of a gang, especially a black gang, the white man is your number-one enemy because all the gang members see is a white man coming to arrest them, putting them in jail, and giving them their time.

Today, I believe that all people are good. I believe in a third race where everybody is equal and there are no colors. I look at a man's heart. Young people, especially young people in gangs, and it doesn't matter what color they are, need to understand that there is a human factor that underlies skin color.

After the Los Angeles Uprising, Fred asked me to go to Korea. In fact, I was pissed off at Koreans for moving into my neighborhood and building their stores. It took me a while to understand that before they had come, those empty buildings could have been occupied by the African American people, but we didn't take advantage of it. So I went to South Korea and met Donald Gregg, who was the one who wanted African American kids from Los Angeles to

come. He said that he was going to help us out so that we could return to Los Angeles and help to rebuild relations between the blacks and Koreans.

I had seen many Korean and Cambodian merchants in my neighborhood, but I didn't deal with them because I didn't like them. I found out later that the only reason why I didn't like them was because I didn't know them. I had picked up a little Korean on my trip, so now when I entered their stores and used the phrases, they lit up like they had seen Jesus Christ. That opened doors. One merchant told me that before coming to Los Angeles, he had been informed that black people were animals and all they did was rob and steal. So for the past two years, I have been trying to find every Korean from Los Angeles to Long Beach to Compton to let them know what we are really like.

I have two kids to raise. Regardless of whether I am in Beverly Hills or the lowest part of Compton or Long Beach, I want my kids to grow up in a safe environment. I may never be a millionaire, but I want my kids to say that I did this or their dad is a part of that. Some cats in the gang have eight or nine kids, but they won't stop to understand that they are not only hurting themselves and their race but they are hurting their children as well.

I do have a responsibility to the community and to myself. I also have a responsibility to Fred because without him I would still be in jail or dead. He changed my whole outlook on life. I also have a responsibility to the New York Korean Society for accepting me. They gave me major self-esteem because before working for them I had never received a paycheck in my life. Do you know how that makes someone feel to receive a paycheck? It made me feel like a real man. I felt like someone who is taking care of his responsibilities and will now shy and stay away from trouble.

Omar Wasow

Born December 22, 1970. **Omar was born in Kenya, grew up in New York, lived in Puerto Rico, and has a white, Jewish father and a black mother—so he has been exposed to many cultural models. Though he has wrestled with his identity as an African American, he has resolved most questions, and is now at the pulse of New York's African American community. Omar is the founder and president of New York Online, an electronic bohemia that stresses intimacy and diversity and is the largest black-owned online service in the country. He has been profiled in the *New York Times*, the *Village Voice*, *MTV*, the *MacNeil/Lehrer Newshour*, and *Wired* magazine. In 1996 he was named by *Newsweek* magazine as one of the most influential people to watch in cyberspace in its article "50 for the Future." He resides in Brooklyn, New York.**

One of the most transformative periods of my life occurred when I was a student at Stanford. When I arrived, I felt totally alienated from the black community on campus. At the time I was pretty illiterate about race politics, as I had come from New York, where there was this *one world* vibe. For all of the power that idea has, it also shelters you from the harder realities.

For example, the black community on campus was really polarized at the time. It was hard as a freshman to figure out where I fit in. As a result I stayed on the periphery. But by the time I graduated I was a resident assistant in the Black Theme House, one of the minority-focused dormitories where those living in it are 50 percent or 60 percent of a particular racial group. I went from being marginal to being at the center. I was in a place where every time I left it I felt like the rest of the world was not as comfortable or as familiar. It's surprising then that not only did I become savvier about race politics in this country but I also became more at peace with the world. It might be because the experience gave me real love and respect for black folks and our history.

I have no problem accepting it as my history, but I do have a problem with the notion that if you are not black and not white, then you are in the middle. In a lot of ways that ignores all of the history and politics that have existed for hundreds of years in this country. That there is no middle is not logical. But race is not about logic. It is a social construction that has no grounding in reality. It is about a caste system.

When I was identifying as mixed in high school, I was ignoring the fact that it was easier for white people to deal with me than if I said I was black. There is more comfort if you have light skin or if you are more white-looking. I have white friends, and I am perfectly happy to hang out in a crowd full of white people, but as a matter of choice, I don't like to put myself

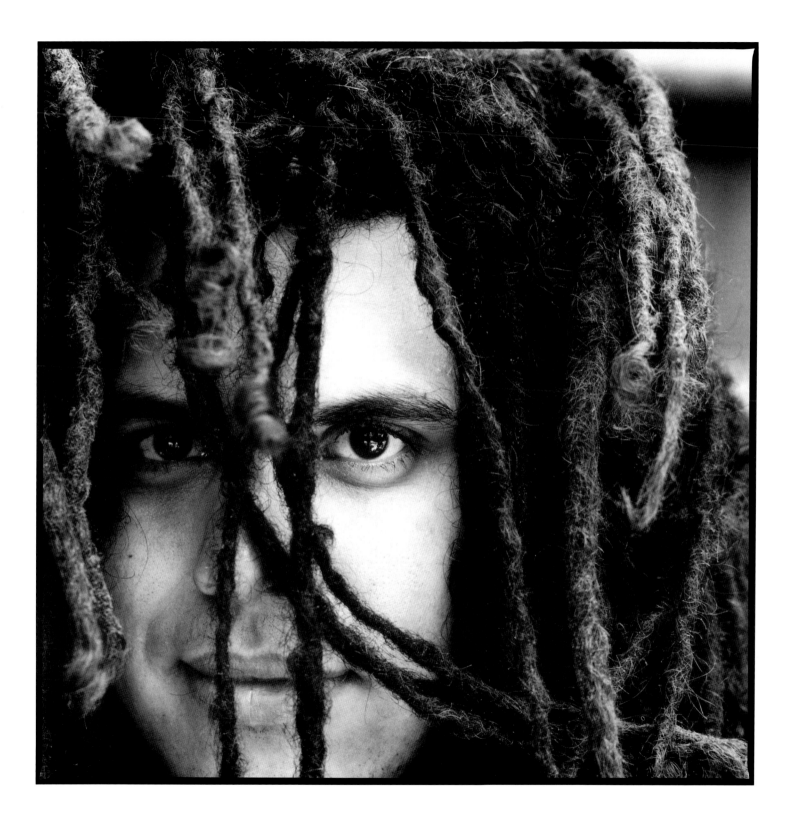

in the minority. I don't like being in the minority, period. The level of alienation that mixed black kids and black kids who have grown up in predominantly white environments feel is a hard thing for people to grasp.

I remember one time talking about my experiences and admitting the crime of all crimes in the black community—that I had a white girlfriend. I looked at all the black faces in the room and nobody was laughing or whispering or anything. At that moment I realized that all of them had their own issues, traumas, and problems. Every one of these people was an individual with their own problems, and I didn't need to worry about them pulling rank on me. Once I had the sense that nobody was more than me, it became easier to just hang out and to be not at all concerned that I didn't belong.

After graduating, it seemed to me that where the black agenda had succeeded over the last fifty years had been in legal fronts. For the most part black people can move freely in this country. There aren't the legal restrictions that were in place fifty years ago. So becoming a lawyer, which a lot of people encouraged me to do, didn't make a lot of sense to me because I didn't believe that was where the action was. The issue was much more about economics than about law. There was something really powerful about business, and I knew that I could only learn what it was by being in it. I also knew that the experience of being in business was going to be far more valuable than any particular income it generated. That has been true to this day. It is about wanting the knowledge more than the capital.

I think a lot of what I have learned I could have learned selling T-shirts. But the other thing that has been nice is that I went into New York Online with a love of computers, and it turned out to become the biggest craze of the decade. Much of what people do online is play with identity. By understanding identity, I have a much better understanding of what to offer people online and how to make online services work.

I didn't know what the answers would be, and I wasn't even sure what the questions were, but I thought this would be the best place to find it. To some degree I think I have found it. There are few things more thrilling than to have some sense of knowledge that excites you. But there is also superficial success; for example, the great deal of publicity under my belt. It is very clear to me that it is very short lived and that I can't focus on that as my measure of success. In a long life and with a lot of hard years ahead of me, it is important to be focused on things that satisfy me in deep ways. Being twenty-five is mainly about learning. So for me, the degree to which I succeed is the degree to which I am challenging myself, working as hard as I humanly can and gaining knowledge from that.

Radcliffe Bailey

Born November 25, 1968. **Radcliffe is a painter and artist who feels his mixed media canvases are very much indebted to the traditions of African and American art. Radcliffe has had numerous solo and group exhibitions dating back to 1990. The Atlanta International Airport displays a permanent installation of his work, and he has collections in the Chicago Art Institute, the Denver Art Museum, and Hammonds House in Atlanta. He is represented by the Fay Gold Gallery in Atlanta, Georgia, where he resides.**

I think the only person who pushed me toward the arts was my mother, who was a school teacher but also my real teacher. She got me interested in museums, going to plays, and meeting different artists. But many of my family members were role models.

I remember being so fascinated with my grandfather when he would make birdhouses. He used to tell me about his relationship to the birds and their relationship to people. I didn't look at him and see a man who made birdhouses. I saw him as a philosopher. When I go to the barber shop, or church, I hear old people having conversations about life. The idea is communication. I think that's what everybody wants to do.

In fact I had many support systems from friends and family. If I had a problem, I would cry, but out of crying there would be someone who would listen to me. I have always had people around me who have helped me. I have needed that support because I have also had to deal with some difficult shit.

When I was in the fourth grade, I was held back because they said I had a learning disability. Then I had to be in class with my younger brother. You go throughout your childhood with other kids scarring you with, "How did you get here? You're not twins." So I became the kid who sat in the back of the class. But it was strange because even though I would sit in the back of the class, I felt just like I did when I played catcher in baseball, where I was facing the whole field and making the calls. So even though I doodled, stared out the window, and daydreamed, it was just a part of who I was then and who I am now. I feel as if I should see the whole world and own the whole world.

My art takes me to those different places, and it is a voice for me, but it's not my only voice. I haven't even recognized some of my other voices yet. It also heals me spiritually. I sometimes paint about personal problems, or relationships, or the pain of a grandmother or an aunt dying.

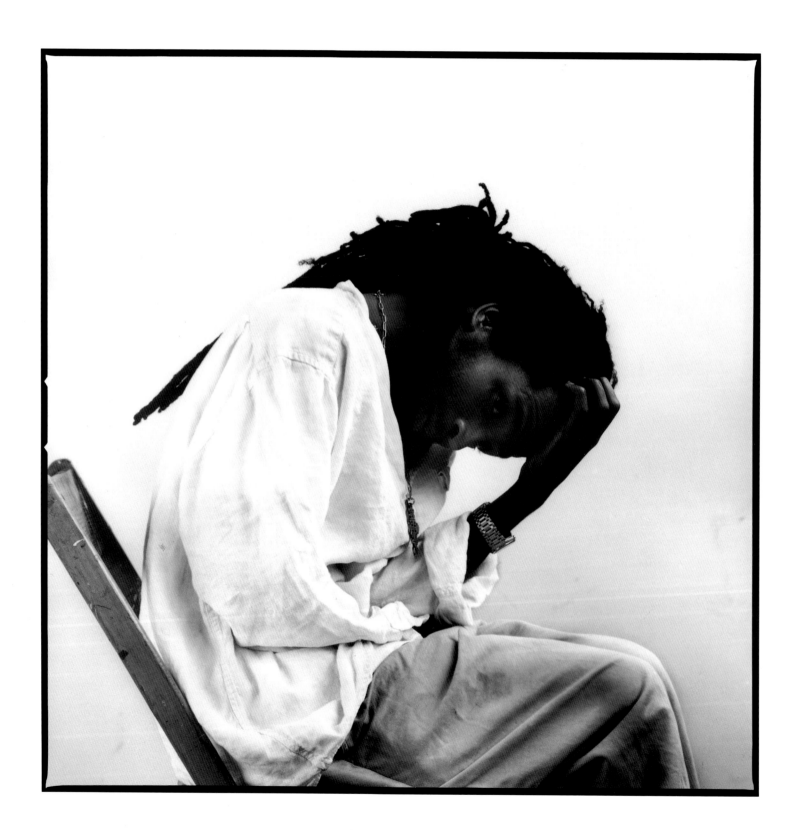

I paint on the canvas and in my mind. But painting is not about the material. I see myself as coming through different cosmos and dealing with the different materials that are in those cosmos. I don't know if the next cosmos, or wherever I go, will even have paint. The key is to be able to communicate with people who have been down the same road. It is being able to listen to what they have to say and walk away with something that will help you, and in the process you open doors that have never been opened before. That is what it is really about: passing down keys to open those doors.

I'm not necessarily concerned about things that are tangible. It's what musicians sing about when they say "going to the crossroads." The crossroads deal with crossing over to the other world where things are not tangible. I think that is what a lot of African art is based upon. There are forms that are not figurative; some of them are, but some are geometric shapes that deal with the representation of the other world.

I see myself as a thinker more than a painter. I think I can communicate moods and feelings through painting or making things. I want people to think about my work and not just walk away thinking that it's weird, *out there* art. I want them to realize that I go by an aesthetic that has been passed down to me by African American artists and several artists from around the world. I have been influenced by those people who didn't need to be guided but were guided by a higher being.

Someone may ask why I use indigo blue in a painting. It may be because I was fascinated by the blue that amongst the Yoruba showed a certain amount of power. Or, it may have been the blues in music, and then that would lead me to Coltrane. Sometimes I give a color eight different meanings.

My work is really about music. There is an aesthetic that's based around music. When I think about a lot of traditional African art that sells around the world it's always based around music, and music is always based around ritual. I don't think you could ever say that it doesn't have that power.

Thelonious Monk once said about recording a song for an album that when someone would ask him to play it again, he would say, "Damn, I just played it. Every time you play a song you lose the power of it. The first time is always the best." What is the point of standing in the same point painting the same thing that's been painted since the 1950s. You have to transcend that. That is what my painting is about as well. I want to go out and name the unnamed.

I'm for humankind. My ideals are different, but I can't be narrow-minded in my thinking to just do something for only a group of people. I think about the larger group of people. When I was younger, I had to become somewhat of a fighter and deal with it in a different way. It gave me a challenge, which turned out to be the best thing that ever happened to me.

I remember being at an assembly called "Black Men, Image and Reality." It dealt with the stereotypes of black men and after the event I was hanging around with some friends and got into a mix with some people who came up to me about my hair. I told one of them to grow up. To be a man he had to start something and hit me in the head. I started toward my car, and they chased me down the street to an alley and shot at me around eight times, and one of the bullets went through my leg. It was at that time that I realized that I was here for a reason.

My work hits people after they see it. It could be a very memorable hit, or it could be subtle. Just like music. Everybody likes certain songs or certain tones. Somebody may really like my music, and they hear it ringing in their heads. That's the most joyful thing to get out of it. You don't need to own a painting because you own it when you see it. You have it in your memory.

Ralph Bryant

Born August 21, 1970. **Ralph acknowledges and respects the strength of African American women; without the support of his women neighbors, he and his brother might not have survived their childhood. Ralph is now working within his community to help other youth. He is the assistant director for special projects and publications of Youth Unlimited, the youth leadership center of the Citizens Committee for New York City. His work has been featured in the *New York Times, New York Daily News,* and *Good Day New York*. He is also an accomplished playwright whose first play, *So Now You've Got It*, was performed to sold-out audiences at the Abrons Arts Center in New York City, where he resides.**

My first childhood memory of my father is when he moved out. I was around two years old. Afterward he would occasionally just show up. One time I was jumping rope, and he, being this very macho, strong guy, snatched me out of the game and took me straight to a tae kwon do school. Girl stuff was not what he wanted his son doing, even though he was not around to tell me what he did want me to do.

One of my problems growing up was that I was very negative toward my stepfather. In retrospect, I see that I had thought it would be unfair of me to be supportive of him when my father was still kind of floating around. My mother had a serious history of mental illness; she had a combination of schizophrenia and manic depression. When I was fifteen or sixteen years old, she was in the hospital for about the third time. My younger brother and I were taking care of each other, and we were doing really well because we had supportive women neighbors who would feed us when we didn't have anything to eat. Then, my father decided that he would come and take care of us. For two straight months, he would take the welfare checks that were supposed to support me and my brother and leave without a trace. We didn't see or hear from him until the next check came in. After the second time, I told him that we didn't want anything to do with him. Soon after he had left, I got involved in my first youth program. That was the beginning for me. But it also marked the last time that I ever spoke to my father.

I think I have much more of a real understanding and reverence for women because of the strong women who were in my life at the time. Since the men in my life had let me down, I acquired a sense of commitment that I need to be there for young people and for my four-year-old daughter. I have to raise my level of commitment for myself, for my neighborhood, and for all of the people who invested their time in me. Those women still keep me in check today.

I see my daughter every weekend and sometimes during the week, depending on my work schedule. I want her to learn that as hard as it is growing up, and although it sounds like

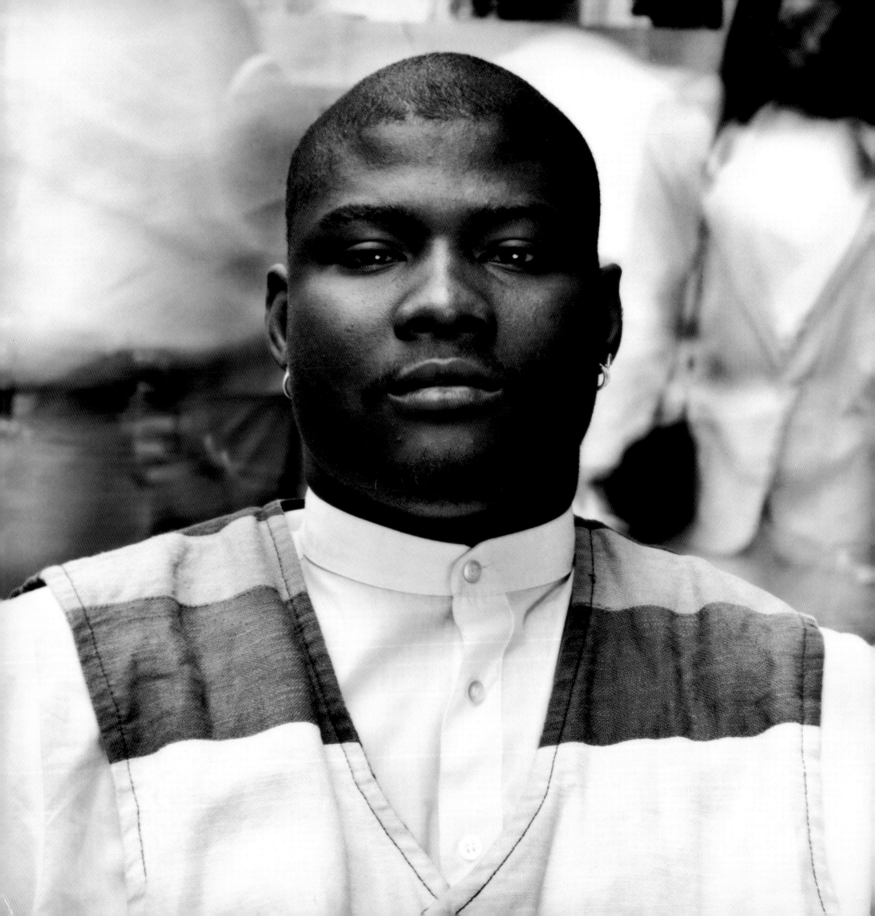

a cliché, young people should never give up, and she should know that I will always be there to support and love her regardless of what she does. I certainly didn't have that from my parents, but I had it from other people.

I want young people to realize that they have an incredible stake in their future, and they do not have to wait until someone hands them a road map for how they should live their lives. If they see something that is wrong, or in bad shape, they should mobilize to change it. That will give them as much power as anything negative could possibly give them.

At times I find myself crying at movies and doing all of the stuff that men are not supposed to do, but I think that the definitions of men and women are changing and have changed rapidly. In large part, men have had to respond to women who decided they were not just going to be homemakers. Instead, they decided to be more aggressive and do what they had to do for themselves. As a result, men have had to modify how they deal with women and how they approach women. Fortunately for me, I have not had to tailor myself too much because I grew up with a bunch of women who made sure I toed the line.

There is a great division between African American men and African American women. We are finding that African American women are running our communities and have been running our communities for a very long time. In fact, they are not only running our communities but also keeping our people alive. In youth services, it is African American women who are in the driver's seat. They are in positions of leadership and power.

For me, being a man means accepting a responsibility to be responsible, and that means being responsible for my family, my community, and my world in a global sense. Part of that is to make a commitment to working in partnership with women and other men to be able to meet those responsibilities. I think the problem that sometimes happens is that women think that if you are pro-man, then it also means you are antiwoman. The same misunderstanding occurs if you are pro-black, then people think you are somehow antiwhite. I disagree.

Along those same lines it is also unfair to deny a white person the right to be proud of his or her race, just as it is unfair to deny an African American pride in his or her race. I choose to disagree with the belief that people who are pro-white are anti-everything else because when I say that I am pro-black that doesn't mean that I am anti-everything else. I think all I want for my community is for it to decide that enough is enough. We need to rise up and empower ourselves to change the quality of our lives.

Randall Slaughter

Born October 23, 1968. **Randall is a Fire/Medic in the Atlanta Fire Department. As a Fire/Medic he cross-trained as a firefighter and a paramedic, and his work brings him in daily contact with the entire gamut of society. He has been in the military since 1988, currently serving as a sergeant in the United States Marines Reserves. He is also working toward a management degree at Georgia State. He resides with his wife, Katrina, and their two sons, Omari and Corey, in Lithonia, Georgia.**

Drugs have been running rampant in our territory, and we see a lot of gang violence, drug-related homicides, shootings, stabbings, robbings, and prostitution. It's all there on a daily basis.

I try not to lose hope, but it really does take a toll on me. I keep my strength only because of my wife and kids and from giving back to the community. It is why I stay so active in the community and why I joined the NAACP—I had to join some organization that I thought was trying to uplift. Uplifting this community is not a one-man job. The best thing that you can do is hope to be a spoke in the wheel turning in the right direction.

Much of my inspiration came from my mom. She has been with General Motors for about twenty years and was one of the first African American females hired. When she was laid off, she went back to school and got her associate degree in funeral services. I look at her, at fifty-plus years, and think if she can return to school and change careers at forty-eight, then there is nothing I can't do.

One of the toughest things I have had to do is get through the Marine Corps boot camp at Paris Island. It lasted thirteen weeks, and every day was miserable. We got to the island at about one-thirty in the morning, when it was pitch dark. They didn't want you to see how you actually got onto the island. I didn't see the gates coming back out until I graduated and that was exactly how they wanted it. I came in with a little attitude and a little cockiness, but they broke that quick.

After you leave boot camp, and depending on your specialty, you go to school to get your training. In boot camp you are forced to be right there together at all times. But at school people started to break off into cliques because they have a choice. I had a roommate from Maine and I noticed that every time I got out of the shower he looked at me strangely. Once we got to know each other, and he thought I wasn't so bad, he said, "Slaughter, I am going to tell you this, and I hope you don't take it the wrong way, but I used to look at you because I had never seen a black person, and I had always been told that black people had tails."

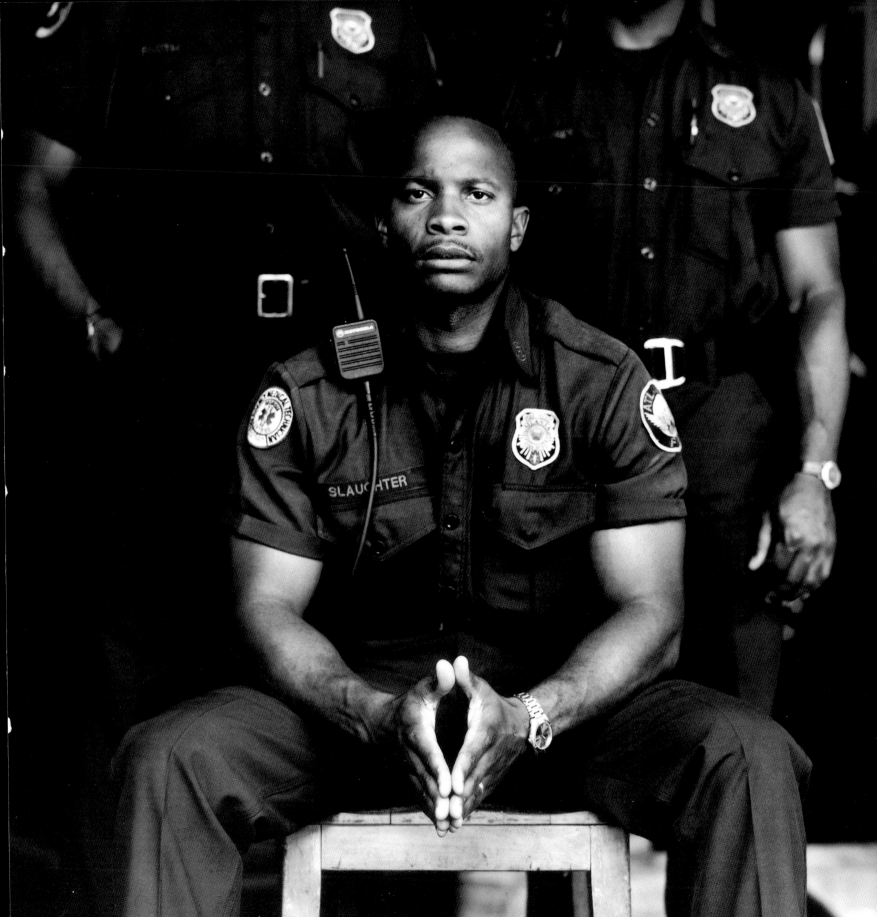

It was no joke, and people don't believe me, but I didn't get offended because I saw the sincerity in his eyes. He wasn't trying to insult me or make fun of me. He was really letting me know how ignorant he was. Believe it or not, I still talk to him to this day because he turned out to be a nice guy.

I am always aware that I am a black male because society doesn't let you forget. You walk into a store and you are a suspect. I am taking classes at a white school this quarter, and I am the only black male in my class. It is always like that. Sometimes there may be two or three other black students in my class. Although I don't try to, if you can forget you are black, you're good.

African Americans have to stop looking for help because it is not there and it is not coming. You can place blame for your situation, but eventually you will get tired of doing that. As soon as you can grow into, and like, who you are, then people around you will start to gravitate toward you, and they can't help but respect you. Where I draw the line is when somebody starts to demoralize me or my race.

I have noticed some of that on my job when different levels of care are given to black patients as opposed to white patients. I have noticed that both white and black firefighters are guilty of this. It is almost an unspoken rule. I have gone on calls that were so similar it's scary. In one instance there was an elderly white lady who was hit by a car up in Buckhead, a ritzy part of Atlanta. She received three or four fire trucks and two ambulances. There were so many people working on this lady that I was wondering how I could possibly be the Fire/Medic and not have anything to do. On the other hand, I have been on calls where a young black male has been shot in the face, and with that you need all the hands you got, but there, I will be the only one working on him. Everybody else just kind of steps back. I don't think it is a conscious thing; I just think people feel more comfortable working on the lady because she looks safe. Another reason may be that it has reached a point where it doesn't even shock them anymore. The feeling may be, "Oh, another one shot and another one dead."

Another subtle difference that I notice is that no matter how old, well-educated or well-dressed a black patient may be, they are always called by their first name. Whereas white patients are called "Sir," "Ma'am," "Mr.," or "Mrs." You notice subtle things like that after you run thousands of calls. It seems that once you get on the job, you start to conform to what is going on, whether it is right or wrong.

I guess I just want everybody to realize their potential, not just me. Everyday I live my life to the fullest, so I hope that everyone else can go after the things that they want.

Sekou Byrd

Born February 22, 1971. **Sekou, who was named after the first president of Ghana after it received independence, was raised in the Nation of Islam, religious followers of Allah and the Honorable Elijah Mohammed. Although no longer in the nation, his early experience with it often made him separate from others, and now he is using the skills he cultivated at that time as a film director to observe and document the human dynamic. He is a senior at the New School for Social Research, where his concentration is media studies. He is currently working on a documentary partly based on the life of his mother. He resides in Brooklyn, New York.**

I was born into the Nation of Islam and went to a nation school. I grew up separate. I don't know if it was a result of the nation, but I didn't really interact with people outside of the nation until I went to public schools. At that point I was so different because of all of those years of not interacting with others, I'm not sure whether the experience was divisive or just different.

I was born in East Palo Alto, California, and it's funny because I remember the town library being on one floor of this big municipal building and the welfare office on the other. Most people were on welfare, and the outside perception now is that the face of our community is a basketball hoop or kids selling drugs. It's all you hear, but it is not necessarily the case. The fact is that there was a library and other outlets.

The best thing that ever happened to me, and I am still feeling its effects on a day-to-day basis, was realizing that although there have been a lot of definitions for me, I could take on different perspectives of who I was as a person. Although I do identify with what is termed *black* and what is termed *male*, I have realized that my own personality is separate and different from everything else. At the same time, however, I guess those terms shaped me. By deconstructing being black, male, and young, I felt renewed or reborn. I am more concerned with realizing who I am rather than having to fit into a set role or character.

In order to communicate with certain groups, I have to fill the role of African American male. When I am comfortable with it is when someone else is defining themselves as an African American male; otherwise I can't really describe what that label means. My personal belief is that everyone comes from Africa, so all men and women should identify with being African.

In this country, even before they attribute it to me or anyone else, there is such a definite idea in people's heads when someone says "black man." They just have a picture in their

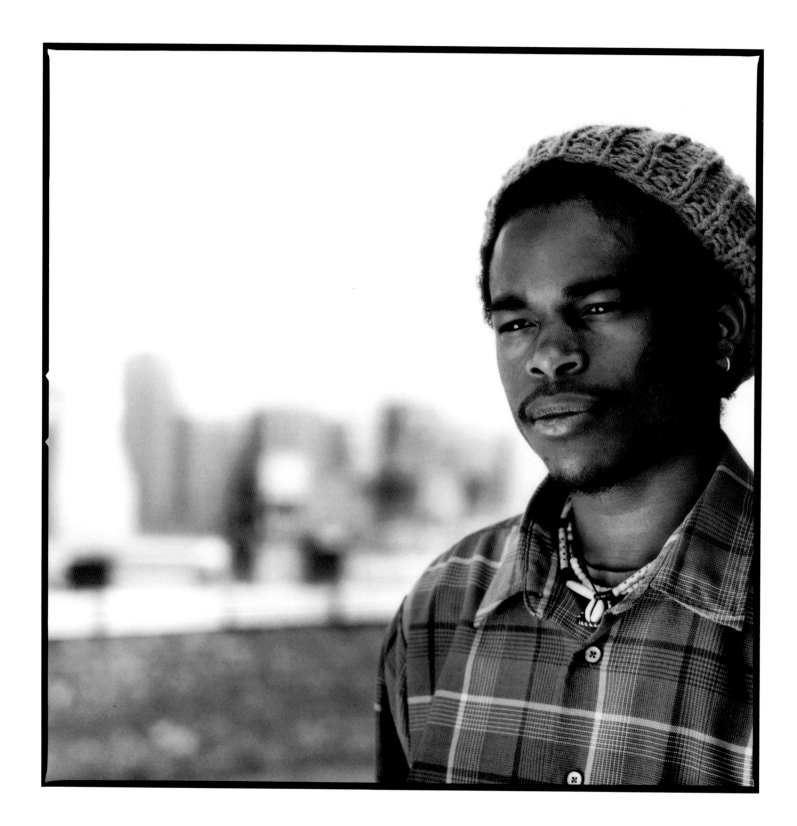

heads that could be one of a number of things. There is a part of me that doesn't want to upset their view. In addition, there is a part of me, even if that view is upsetting to me, that wants to add to their perception in some way.

I have had to confront violent responses to my challenging people's ideas of what black people are. For instance, after moving to Oakland, I would get beaten up and jumped by other black people for just talking different and being considered an *oreo*, black on the outside and white on the inside. Another manifestation of it was from white cops in my neighborhood. One night I was at a party and shooting broke out. I saw a cop and flagged him down. He told me to sit down on the back seat of his police car. I thought that I was just resting to tell the story, but he closed the door on me. So now I was locked inside. Later on more police cars came, and I started pounding on the back of the window. By the time the cop came back, I was pretty incensed for being locked in his car, and I asked him why he had locked me in the car. He didn't even address what I had asked him. So I asked him twice, and then I yelled. He said, "Alright, try it." So I put my hands in the air to show him that I was not trying anything and that I just wanted to know why he had locked me in the car. He went on to say that I had spit on him. Simply put, he locked me up and I spent the night in jail. I was arrested for assault of a police officer.

I found out that the regular routine for cops in Oakland is to bring in black men because they believe that black men usually have warrants. In this case it had the effect of influencing me not to flag down any more cops. You can believe that. I was talking about being a witness to a crime, and I ended up in court defending myself.

I have been influenced greatly by James Baldwin, Kwami Mfume, Patrice Lamumba, and Sekou Touré. They were all considered to be black men, and some were not even American, but they all had a more human perspective. Being black wasn't the connection. It didn't seem as if their minds were about being or defining or understanding a definition of color. They were concerned about something else that affected everyone. They all had different views on the world outside of America. This microcosm that we live in was not the end-all and the be-all of life.

Touré

Born March 20, 1971. **As a freelance journalist, Touré often finds himself grappling with the narrow ideas people have concerning what subjects are appropriate for black writers. He has written feature articles for *Rolling Stone*, the *Village Voice*, the *New York Times*, the *New Yorker*, and *George*, and along the way he has tackled those limited parameters firsthand. He was previously a news writer for MTV news. He resides in Brooklyn, New York.**

My parents are very middle class, and they wanted me to be able to do a number of different things. They wanted me to play the piano a little bit and ski a little bit; it was a very liberal arts childhood. But I never felt like that was the way it should have been done. I am not a jack of all trades. I don't do a lot of things. I just write. That's all I really care about.

Recently, I read a quote about writers that said, "Nobody has a good first draft, and the thing that separates the good ones from the great ones is how many times you are willing to go back to it." That is something that comes up over and over again as a writer. How obsessive are you willing to be? The writer is the one who has the drive to keep going when you are deadened, when you can't see the words anymore, or when you've already read the draft thirty times.

I have been very lucky in that I have done what I set out to do. People who are successful have a knack for putting themselves in the right company or in the right place so that their talent can be recognized. Nobody creates success themselves. You have to find a mentor or someone who will either pull you up or help you open a door.

When I was interning at *Rolling Stone*—one of the first things I did when I came to New York—I didn't do any of the typical intern tasks that I was supposed to do. I just tried to meet the important editors, and I was lucky enough to be able to do that. After I got fired, I was able to come back as a writer because one of the editors liked me and wanted to give me a chance.

I love so many aspects of this job. The writing, the feeling of writing, coming up with ideas. You have to be a cultural student, and you have to know what is going on. Where are the trends? Who is important? Then you have to be able to pitch the story. If you are going to be in a good magazine, you have to be able to know how to pitch almost as much as you know how to write.

Unfortunately, there is no way to avoid racism along the way. One time, an editor came to me from a renowned magazine because he wanted me to write about a day in the life of a drug dealer. I was young enough to first think, "That's cool." Then I sat back and thought, "I don't write about drugs. I don't write about chemicals or science. I don't project myself as an

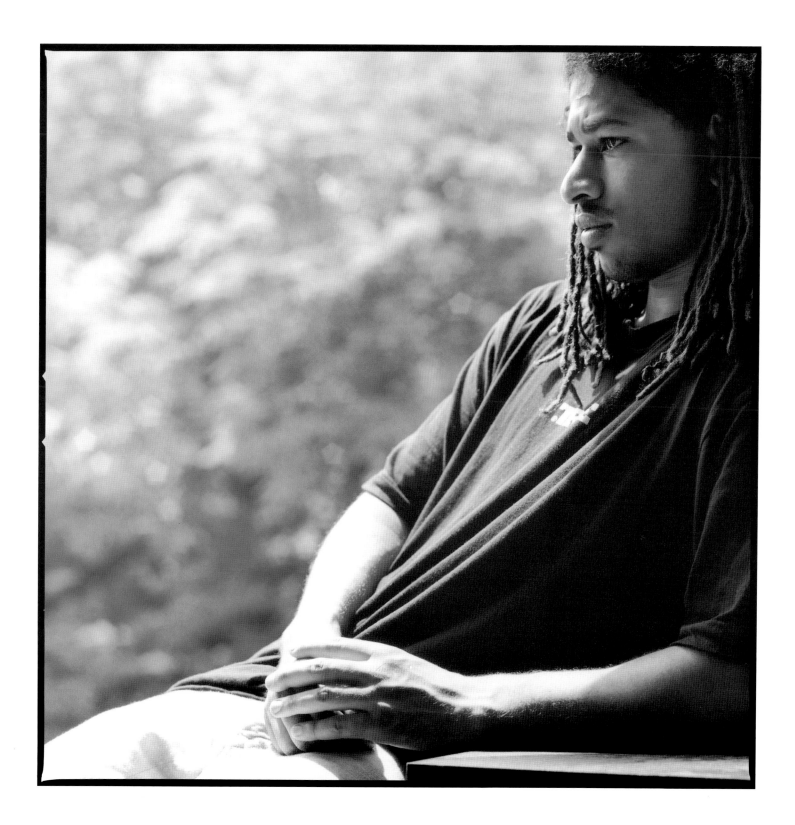

expert on heroin. Why does he want me to do this?" I realized that he thought it would soften the blow if he had a black writer write the article. The only drug dealer I knew at the time was a white guy who sold drugs all winter and then went on incredible trips trekking through Asia and Africa. I went back to the editor and answered his nine questions about the drug dealer, his past, his whole M.O. He was loving my choice straight down the line. Then he asked me if the dealer was black, and I said, "No." Suddenly he was in a totally different space. He said, "Oh, we were hoping for somebody more downtown." Finally, he said he would call me later. Needless to say, I haven't heard from him in three years.

There is also the issue of whether I can write about white subjects. It is never questioned whether white writers can write about black subjects, but there is always a question about a black writer covering someone like Tori Amos or Eric Clapton. First and foremost, if I am a decent reporter, I can go home and figure out Eric Clapton. There is nobody who is so complicated that I couldn't figure them out. With that said, when I do write about black subjects and situations, I want to show it with all the complexity that it affords. But what I sometimes get from black people is that they want me to be an image custodian. I am not a journalist to them. They want me to make them look good. I think that we have a tendency to be too sensitive in the way that we look at each other.

When I was working at MTV, I did a piece on the artist Old Dirty Bastard. His whole shtick is to act like your old drunk uncle. I went out and I interviewed the guy, and the first thing he wanted to do is go to the welfare office where he used to get welfare stamps. I told him that when he looked at the camera he should talk about being at the office as how it used to be. He put the welfare card in, and with the camera right behind him, received $350 of food stamps. He came out, counted the money in front of the camera, put it in his pocket, and walked off. Outside there was a limousine waiting to take him to the next location. So I ran the story and tried to make the piece as good and as interesting as I could. I felt guilty about the way it looked, but I thought I had to make a strong piece first, and he knew what he was doing. When it came out, no one was concerned about the way he acted, instead they thought that MTV was trying to make rappers look bad. With black people and black culture the politics is never far from the surface. However, there isn't an overt politicalness to my work, anymore than there would have to be with black people.

I think the greatest gift I ever received was the example of my father as a worker, as a parent, and as a husband, especially as a husband and a worker. He showed me an incredible example of how to be a perfect husband who is always there for his wife.

Tucky McKey

Born January 8, 1969. **Tucky is a cartoonist whose strip,** *King and Kango,* **appears weekly in the Pacific News Service publication** *Yo!* **He is an accomplished animation filmmaker who has won an award from the Black Filmmakers' Hall of Fame for his video** *Life Could Be So Nice.* **He is also an instructor with Families First, a youth counseling organization focused on providing additional support for inner-city families. Tucky resides in Oakland, California.**

When I was eleven years old my family moved from South Central to Concord, California, an all-white community. I had never even heard of it, and it wasn't even on the map. The kids who lived next door to me were trippin' on me because I was the first black kid they knew. I would talk about South Central, and the kids would think I was lying because they didn't believe people killed each other just because you might be wearing red or blue.

They thought I sounded southern, and over time I started talking like them. I had to adjust to a different code in Concord. I got into a couple of fights, but eventually I stopped fighting and just concentrated on drawing and music. The reason I started drawing was because of Albert Gillery. When I was eight, he was an inspiration to me. I remember the teacher asking him to go up to the board to draw a turkey, since he was the best artist in the class. He drew this perfect turkey, and I was just jealous of him. I started drawing after that, and all I wanted was to be able to draw the way he could.

After I graduated from San Francisco State I made my first film about this superhero, Master Disc, whom I had invented when I was little. To deal with my nightmares and be able to go to sleep, I would dream about Master Disc coming to save me.

Now, in my comic strip, I have two main characters. King is the innocent, unconditioned black youth, and Kango is the kid who has been through everything. I really want to know them, and by doing comic strips I am finding out all the things that they can do and explore. One thing I really want is for it to be a black strip. Although humor is universal at times, newspaper comics don't have black characters. They are tokens, if they are there at all. Even in the *Los Angeles Times* all the comic strips are white characters. Why is it that black kids are always looking at white things? For that reason, I think I'll stick to keeping it a black strip.

I want to draw something with black characters that's imaginative but doesn't necessarily have to be dealing with African American issues. When I am with my friends, we don't always talk about somebody getting shot. We talk about our cars or girls. Things like that.

Although my parents are my role models, I used to get mad at my dad because he lectures.

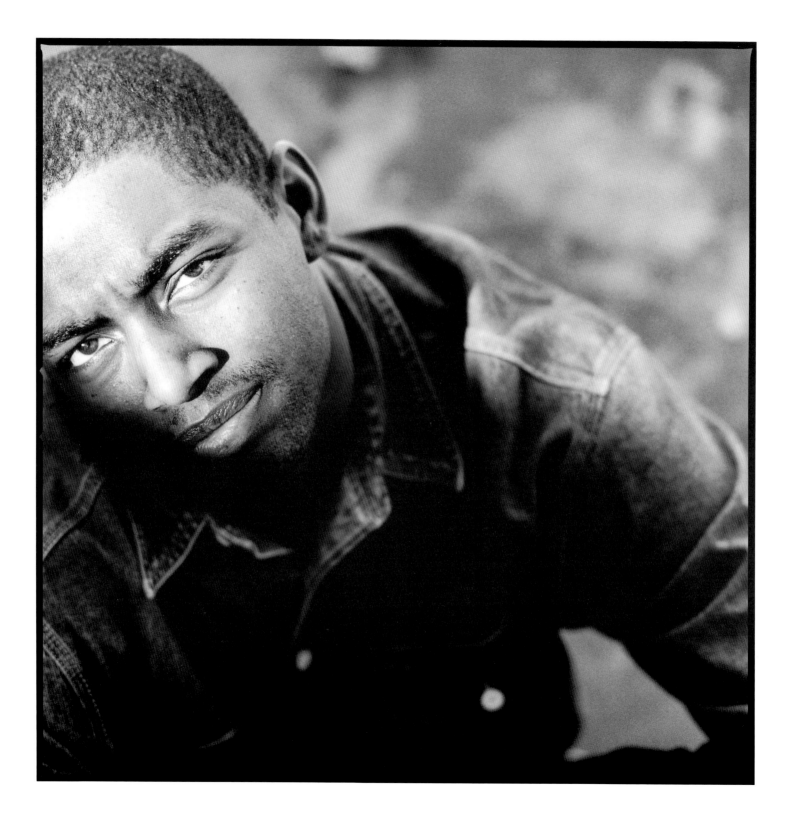

My friends would come over, and I would tell them not to ask him any questions, because he will go on. But when I got older I noticed all that stuff would kick in. To me he is a man. A man is someone who handles his business. Someone who goes to work everyday. Someone who takes care of his family. Someone who is good to the people around him.

I really try to concentrate on what's around me. I think that is the duty of anybody. I try to make what's around me happy and then the rest will follow. If I help someone in an area that is not my area, then that's like helping myself. Because if I do something unexpected for someone else, then someone is going to do something unexpected for me. I really believe that. To me, that is what it is all about—inner peace.

If I had stayed in South Central, I would have been more hard core than I am, but I still wouldn't have been as hard core as my friends who stayed. I like being able to relax and talk about things. I don't want to get in no fistfight with anybody. That ain't me. Bad things may happen to you, and you may have to defend yourself, but I think that 95 percent of the time you can prevent what happens to you. Too many people worry about what they can't do anything about.

I think that God is just what you do and how you treat people. Something that my folks taught me is that it is not about words but rather what you do. That's the perspective that helps me professionally and in my friendships. My father taught us how to think. I remember he said that he wanted me and my sister to be free-thinking people and to do what we wanted to do. That's the thing, they never forced me to be anything. They let me decide and make my own decisions.

I also remember my grandmother always telling me to face things head on. I have fears about certain things in my career, but everyday I am trying to figure how to better myself. I see myself as someone who is constantly improving, whether it is from within or through learning how to be more helpful.

I'm an individual, but I feel like I'm not more than anybody. I'm not better than anybody, and nobody is better than me. I don't look at someone who has no money like they are unimportant or less of a human being. I look at myself as an equal to any other human being. Before I used to be more about myself, but my father began to tell me that there were things outside of me. Now I am more open and willing to accept more help than I used to. That is really what has brought me to where I am now.

Tyrone Porter

Born July 21, 1973. **Tyrone admires and respects his parents for the love and guidance they showed him growing up, and now he hopes to extend help and support, as a contemporary, to other Detroit youth who may not have someone to look up to. He began PACT, Peers Advising Counseling and Teaching, while he was in high school, and continues to expand it. PACT has helped more than a thousand black youths find reasons to think positively about themselves and their futures, and Tyrone's work has been featured in *USA Today*. Tyrone is now a senior and an electrical engineering major at Prairieview A&M University. He is the campus president of the National Association of Black Engineers, and he resides in Prairieview, Texas.**

My parents whupped my temper out of me. After a while, I began to fear my father. I always wanted to go and hang with my friends or do this and that, but in the back of my mind I was always thinking about the consequences. That is the one thing that kept me from getting into fights. In the street you could defend yourself, but at home you can't fight back against your parents.

One summer while I was in high school, I had a research position at Dow Chemical in Midland, Michigan. On the first night, a group of us, ten black males and our facilitator, went grocery shopping. I don't think the people in the store had ever seen that many black men together at one time. After we paid for our food there was a police officer standing at the door, and he asked to check our receipts. His belief was that for that many black men to be together, we must have been stealing. When we finally left, there were two police patrol cars outside for the first officer's backup.

Experiences like that affect the way I see the white community. We were pissed off and upset. In Detroit, I had never seen that side of white people because those who didn't move out to the suburbs had a good sense of the black mentality. They were my friends, and I played with them while I was growing up. I had heard about racism, but it is an eye-opener when you finally experience it. In certain areas of the country there are not a lot of black people, so with the mentality that has been perpetuated over the years, and no one to give them a new mode of thought, there is no reason for them to change.

I have learned to deal with my anger and my hate. I now focus it in a positive direction. But to be able to refocus, you first have to open your eyes to the realities of the world. That is partly what PACT is trying to do. My parents tried to show me the right direction, but in a

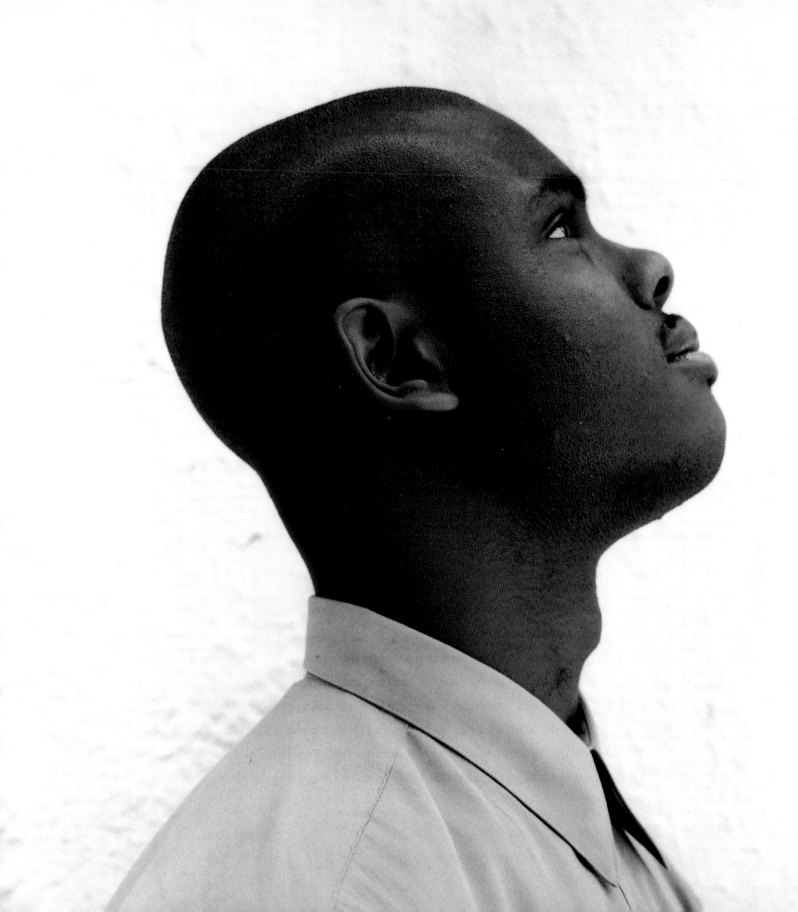

way, my older brother interpreted what they were saying. Your parents talk to you a certain way, and your peers talk to you in another manner.

Not everybody has an older brother, or even parents, who will break down how it really is in the world. So the purpose of the organization is to gather like-minded young individuals who know what is going on in the city. We call it street smarts for common sense. We know what is really going on, and we combine that with talking to young people to let them know that they can be successful. We also let them know what to expect about being black in America.

If you go to a mall in Detroit, it is black. If you go to a grocery store, it is black. It is black everywhere in the city. If you go to another city and walk into a store, there may be only ten black people in the store out of one hundred. It will be a culture shock. Some people say these young people should go to school and learn to deal with the culture shock there, but that is going to take the focus away from their books.

They are going to have to deal with it eventually, and everyone is going to deal with it differently. Another thing we do with the organization is talk about the attributes of successful people. One thing that I see lacking in a lot of young black individuals is self-confidence. So we talk about self-discipline, self-respect, and self-confidence as a way of making them comfortable with acquiring those characteristics for themselves.

In my case my father helped a lot. He would always tell me that I was *the man* and that I was doing great things. Whenever I did well in school, he always congratulated me. It started with him and continued when my two real good friends and I started to play math games. Eventually we went to national competitions in Georgia and destroyed the other students. We won the national title twice. That gave me a certain amount of arrogance, which I only show to people who I know can handle it.

That arrogance I gained is the reason why I only fear disappointing my parents. I remember coming in late from playing basketball one day, and my parents were upset with me. Seven o'clock the next morning I asked my father why I always had to call home and check in. He said it wasn't that they didn't trust me, but it was the fact that it was a dangerous city. If they didn't know where I was, they would worry. It was then that I realized I had been causing all of this strife for no reason, so I decided that I didn't want to disappoint my parents again.